ILLUSTRATED TALES OF
STAFFORDSHIRE

HELEN HARWOOD

AMBERLEY

Acknowledgements

Calendar Customs
Pixyled Publications

With thanks to Mel

First published 2023

Amberley Publishing
The Hill, Stroud
Gloucestershire, GL5 4EP

www.amberley-books.com

British Library Cataloguing in Publication Data.
A catalogue record for this book is available from the British Library.

ISBN 978 1 3981 0776 2 (paperback)
ISBN 978 1 3981 0777 9 (ebook)

Origination by Amberley Publishing.
Printed in Great Britain.

Contents

Introduction

Britain has a varied and fascinating collection of traditional music, songs and stories. Well-known characters such as Robin Hood and Dick Turpin are familiar to most of us, as are songs like 'The Drunken Sailor' remembered from school days. That we know these songs is probably down to the founding father of the folk song revival, Cecil Sharp, who began collecting songs in 1903. Traditional dance too was then dying out, and in 1911, he founded the English Folk Dance Society. Staffordshire, however, is a county often overlooked by collectors of traditional stories but like the coal seams that traverse the county, delve a little deeper and it has a large collection of tales and myths, from dance, well dressings and witchcraft to the superstitions associated with the coal mining industry.

Similarly, the easily recognisable county symbol colloquially known as the Staffordshire Knot, or officially the Stafford Knot, can be found throughout the county. Its long association with Staffordshire and particularly the town of Stafford has led to the development of several stories surrounding its origin. Perhaps the best known is the myth relating to Stafford gaol where the executioner had only one rope and three criminals to hang. Not wanting to dispense one before the others, he tied the rope into a knot of three loops and hanged the three criminals together. Another version tells of the knot being invented by one of the condemned prisoners, thus impressing the executioner and saving himself from the final punishment.

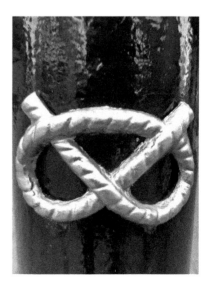

The Stafford Knot, the emblem that represents Staffordshire, which can be found throughout the county. (Author's collection)

An earlier story tells of it first appearance on the heraldic shield of the Stafford family in 1583. However, before then Lady Joan de Stafford – The Lady of Wake (d. 1443) – adopted the wake knot and carried it on her family seal. This has four knots tied by a string around her coat of arms and is now in the British Museum.

Even earlier is the legend surrounding its motto 'The Knot Unites', as Ethelfleda, daughter of Alfred the Great and Lady of the Mercians, built and defended a burgh or fortified walled settlement at Stafford in 913. It is said that she took off her girdle and proclaimed to the local lords 'With this girdle I bind us all as one', uniting the three local areas into what is now Staffordshire. A simpler theory is that the shape of the knot forms a double 'S' for Staffordshire. It is much older though, as the knot can be seen on a 4-foot-high Anglo-Saxon cross in the churchyard of St Peter ad Vincula, Stoke. Furthermore, it also forms the decoration on a seventh-century artefact from the Staffordshire Hoard discovered at Hammerwich in 2009. Given this evidence, the knot is likely to pre-date the Anglo-Saxon and Norman period and is possibly either a Mercian heraldic symbol or a Christian symbol carried by Celtic Christian monks from Lindisfarne to Staffordshire – the three loops being a representation of The Trinity.

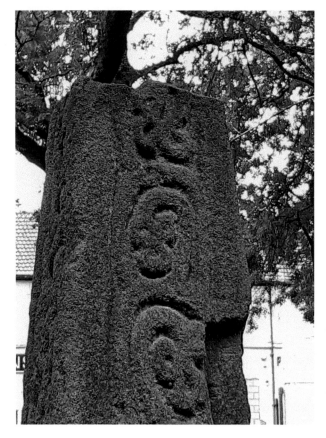

The oldest example of the Stafford Knot on the truncated Saxon cross standing in the churchyard of St Peter ad Vincula, Stoke. (Author's collection)

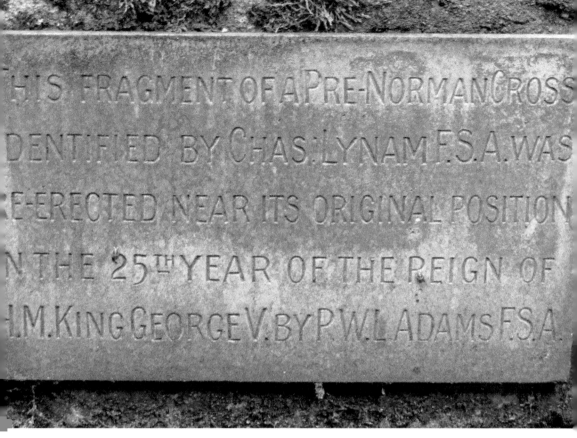

THIS FRAGMENT OF A PRE-NORMAN CROSS
IDENTIFIED BY CHAS. LYNAM F.S.A. WAS
RE-ERECTED NEAR ITS ORIGINAL POSITION
IN THE 25TH YEAR OF THE REIGN OF
H.M. KING GEORGE V. BY P.W.L. ADAMS F.S.A.

The plaque at the base of the Saxon cross. (Author's collection)

The Stafford Knot became so engrained in local culture that at some point it became a dance where the dancers stepped out to form the shape of the knot. Whatever its origins, the motto 'The Knot Unites' is still as relevant today.

Part one:
From Across the County

Abbots Bromley Horn Dance

The Abbots Bromley Horn Dance is considered to be the oldest traditional dance in the country dating back to Barthemly Fair of August 1226 and still performed today on Wakes Monday, the day after Wakes Sunday that is the first Sunday following 4 September. The dancers, six deer-men, collect the three white and three black sets of antlers from the church of St Nicholas where they are kept and join with the other dancers, a hobby horse, fool, bowmen and Maid Marian – a man in a dress – accompanied now by an accordion player whilst previously a fiddler played to perform along a route of approximately 10 miles (16 km).

Removing the horns from the wall in St Nicholas' Church, Abbots Bromley. (Averil Shepherd, Calendar Customs)

'The hobby Horse doth hither prance,
Maid Marion and the Morrice(sic) Dance'

Carbon-dating has placed the antlers to c. 1065 and these may have replaced an older set, which suggests an Anglo-Saxon origin to the dance, perhaps even to the Pagan Lords of Mercia whose hunting lands surrounded Abbots Bromley. To ensure a successful hunt, the foresters would have arranged rituals and the tradition survived into Christian times, when Burton Abbey – re-founded *c.* 1003 by Thegn Wulfric Spot as a Benedictine abbey – took possession of the forests and the dance became a celebration of the villagers' special privilege to hunt on the abbey's land. One story tells that the original horns were bought by the Vikings to Mercia as reindeers were extinct in this country by then. The Danes were in Mercia in the 870s. Following the final dissolution of the abbey in 1545, the lands were granted to Sir William Paget. However, the hereditary office of 'Forrester of Bentylee' – wooded area – continued until the nineteenth century when the Bentley family became responsible before handing it to the Fowell family in 1914. Today they still organise the dance.

While the custom is several centuries old there is no mention of the horn dance element prior to 1532. F. W. Hackwood, writing in 1924, refers to the 'Abbots Bromley Hobby Horse Dance' which was celebrated three times a year

The horn dancers in step. (Averil Shepherd, Calendar Customs)

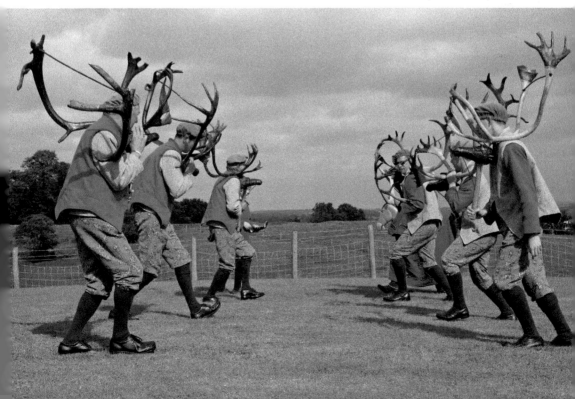

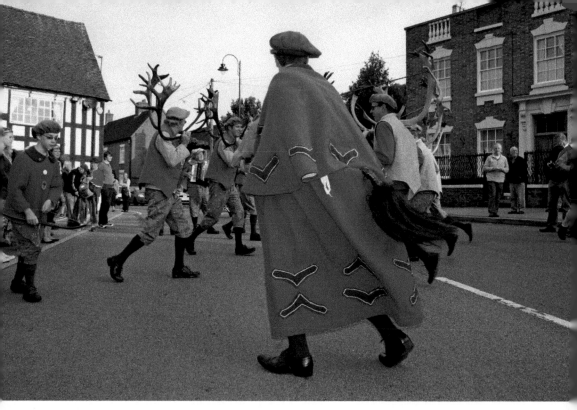

The horn dancers entertaining the audience. (Averil Shepherd, Calendar Customs)

at Christmas, on New Year's Day and Twelfth Day (Epiphany) or according to another writer, 12 May. He claimed that the dance was based on Morris dancing, a custom borrowed from the Moors, via Spain, to England in medieval times. Unusually though, it was celebrated in midwinter and not on May Day, with the steps hailing from an old country dance 'The Hays', suggesting that this was the original tradition and the horn dance was added later. The Hobby Horse Dance was not exclusive to Abbots Bromley as references to Hobby Horse money were found in the parish books of Stafford and Seighford prior to the Civil War where the money was used for repairs to the church.

Throughout the Civil War (1642–51) the horns were hidden probably in the parish church and were not retrieved until c. 1703 when Lord Paget returned home from Turkey. Most likely this was when the horn dance took precedence over the Hobby Horse and bowmen.

Today the horns are the legal property of Abbots Bromley Parish Council.

Chained Oak, Alton

Close to the village of Alton sits the unique Chained Oak or Old Oak, unique as it's the only one of its kind in the world. The tree is around 1,300 years old but the associated legend began in the nineteenth century.

One autumn evening the Earl of Shrewsbury was returning home when he spotted an old woman waiting in the road ahead close to the lodge gate of his Alton Abbey/Towers estate. Stopping, the Earl stepped down from his horse-drawn coach to ask her what she was doing and the woman asked him for a coin. Shrewsbury refused sending her away but not before she placed a curse on him. 'For every branch that falls from this oak tree a member of your family will die.' That same night there was a violent storm in which a bolt of lightning struck the old oak causing a single branch to fall. Afterwards, a relative died suddenly and unexpectedly. Remembering the curse, the by now worried Earl instructed his servants to chain the remaining branches together and so prevent them from falling.

In another version, it claims Shrewsbury was cursed by an old man and yet another one tells of the Earl's son out riding the following day. As the young man passed by the oak, he saw a woman standing underneath a branch which, without warning fell away from the tree, knocking him off his horse and killing him.

While some date the legend to *c.* 1821 when Charles Talbot was the 15th Earl of Shrewsbury, Alton Towers relate it to *c.* 1840s and the 16th Earl, John Talbot. However, the 16th Earl's only son, also John Talbot, died in infancy too early for the legend and the youngest of his two daughters, Lady Gwendoline Catherine Talbot, died in 1840 in Rome of scarlet fever aged twenty-two, so her death was not unexpected. Of her four children, three sons died of measles shortly afterwards, leaving her daughter as the only surviving child. None of these deaths were foretold in the legend.

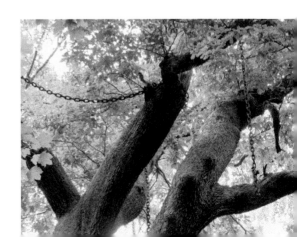

The Chained Oak at Alton.
(Author's collection)

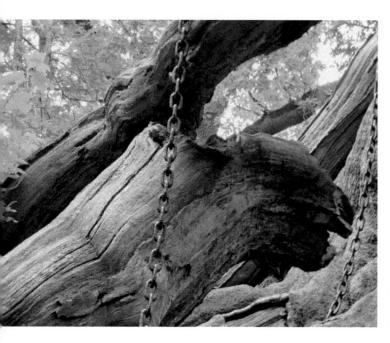

Chains around the
tree's branches.
(Author's collection)

As for the fallen branch, it was supposedly taken to a deep vault in Alton
Towers where the Earl unsuccessfully experimented on it in an effort to break
the curse. Becoming more afraid of it he had the vault bricked up and hidden.
If indeed this was the 16th Earl it was perhaps understandable as the architect
A. W. N. Pugin who worked on Alton Towers described John Talbot as 'having a
nervous disposition'. Only fairly recently during renovation work was the secret
vault's wall discovered behind a bookcase.

Maybe though, there is some truth behind the legend as a violent storm did
occur in July 1872 and then on 11 May 1877 the 19th Earl, Charles Chetwynd
Chetwynd-Talbot, died suddenly, aged forty-seven, in London. This appears to
tally with a report in the *Staffordshire Sentinel* of 25 August 1926 which tells
of the late Lord Shrewsbury over forty years ago ordering that the branches of
the old oak tree close to Middle Lodge at Alton Towers 'be supported by large
crane chains'. According to Mr C. H. Cowlishaw who measured the tree, its girth
at the time was 26 feet and the three main branches 10 feet 8 inches, 10 feet 6
inches and 10 feet 5 inches, respectively. Despite the chains though, one of the
large branches did manage to fall, on 9 April 2007. No deaths were recorded in
the family.

One theory as to why the ancient oak was chained is that it stood close to a
carriageway often frequented by the Talbot family and the chains were a means
to preserve it. Whatever the truth, the legend is the basis for the 'Hex –The Legend
of the Towers' ride situated in the ruins of the tower at the nearby theme park.

Biddulph Moor Saracens

Biddulph Moor lies 1,100 feet above sea level and is the source of one of the country's largest rivers, the 170-mile-long River Trent. There, some 900 years ago, Orm le Guidon, Lord of Knypersley, returned from the Crusades with seven stonemasons, which popular legend claims were Saracens while others say Egyptians or Phoenicians. The latter seems less likely as the Phoenicians were a seafaring people and although they had contact with Britain via trade, there was no reason for them to settle inland. Later accounts tell of a long-established group of their descendants through marriage with local women living on a nearby ridge. Many understandably had dark hair, pale complexions and features associated with the East while some, unusually, had shades of auburn to golden hair and they all spoke in a dialect different to the neighbouring population. Moreover, before transport improved mobility, they were wholly confined to Biddulph Valley and went on to be known as the Bailey family who had varying shades of red hair.

The first printed version of the story was in Sleigh's *A History of the Ancient Parish of Leek*, 1862:

> One of the Lords of Biddulph, a Knight Crusader, is reputed to have bought over in his train from the Holy Land a paynim whom he made bailiff of his estate, and from whose marriage with an English woman the present race of 'Biddle Moor Men' is traditionally said to have sprung. Probably this infusion of Saracenic blood may account for their nomadic and somewhat bellicose propensities.

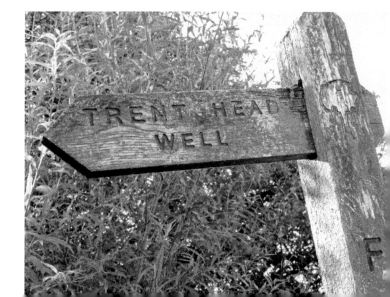

The direction sign to Trent Head well at Biddulph Moor, home of the legendary Saracen stonemasons. (Author's collection)

Trent Head well, the source of the River Trent. (Author's collection)

There was no reference to stonemasons, though the Baily family claim this bailiff to be their ancestor.

A second, lesser-known theory is that eight red-haired stonemasons with the family name 'Bailey' settled on Norton Ridge having been bought over from the continent by the Lord of the Manor returning from the Crusades. This coincided with the time following the First Crusade (1096–99) when a large number of Flemings came to live in Britain sometime between 1100- and 1135. Similarly, there were thought to be Egyptians or Gypsies living on Biddulph Moor and making pots using small 'beehive' like kilns, and over time, with a sparse population, these groups would have intermarried. W. Beresford wrote in his *Memorials of Old Staffordshire*, 1909, 'Amongst the children are seen the loveliest shades of red gold hair.'

The old church of St Lawrence, Biddulph, founded by Orm in the eleventh century, was considered to have had some Eastern influence in its architecture, probably due to the Saracen stonemasons. Sadly though, only the bottom of the tower has survived as the church was rebuilt in 1534 and again in 1835.

Around the side of the church are eight Grade II listed coffin lids engraved with crosses, swords and battle-axes. The swords and crosses are a representation of the Knights Templar who were on the Third crusade (1189–92), suggesting St Lawrence's may have been associated with the order. They could, though, be the tombs of local men who, having gone on Crusade, survived to return home and be buried there. Others are of the opinion they were Norman and the weapons were symbols of their trade.

St Lawrence's Church, Biddulph, thought to be founded by Orm and whose architecture originally had Eastern influence. (Author's collection)

Some of the reputed Knights Templar coffin lids alongside the church wall. (Author's collection)

Moreover, Orm also commissioned St Chad's Church, Stafford, which too was described as being built by Moorish craftsmen. The eleventh-century church is cruciform and on the north-east corner of the crossing. An inscription reads, 'ORM VOCATUR QUI ME CONDIDIT' ('He who built me is called Orm'). It had an unusual font much older than the church which was said to have been bought from Palestine. The font, which is now in nearby St Mary's, is of a Byzantine style virtually unknown in Britain. It is carved with grotesque figures and carries the inscription 'Font Discretus non es is non fugis ecce leones' ('you are not wise if you do not flee the lions'), 'Tu de Jerusalem ror-alem me faciens talem tam' ('Thou bearest from Jerusalem' (the water of life) endowing me with beauty and grace').

Further evidence that Orm may have employed Saracen stonemasons can be found in Spain and southern France where Moorish craftsmen did work on Christian churches of a similar style and age to St Chad's.

Whatever the origins of the story, the 'Biddle Moor' people do exist.

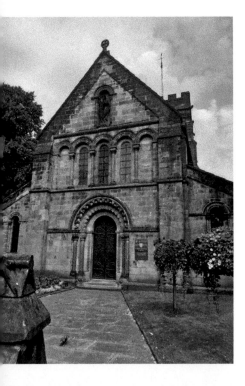

St Chad's Church, Stafford, also built by Orm and the original home of the font. (Author's collection)

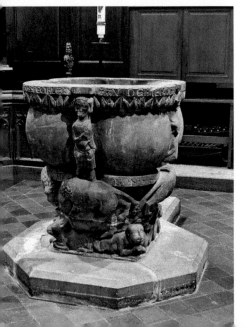

The unusual font believed to have come from Palestine and now in St Mary's, Stafford. (Author's collection)

Our Lady of Brewood

After losing the Battle of Worcester in 1651 King Charles II, escorted by Charles Gifford, fled across the country arriving at White Ladies – a timber-framed house built adjoining the ruined twelfth-century priory and demolished in the eighteenth century – on 4 September 1651. There, George Penderel, who worked for the Giffords, received the king and took him into an inner room where he was disguised as a servant. Incidentally, legend has it that Queen Guinevere is reputed to have retired to White Ladies after the death of King Arthur.

Thanks to the five Penderel brothers Charles escaped before Parliamentary troops arrived at White Ladies, ransacking the house in their search for him. However, the wooden statue of the Blessed Virgin Mary did not fare so well. During the attack, the statue received sword cuts, one above the knee, and a hole to the back supposedly the result of a musket ball. It is from these acts of vandalism that water began to seep out of the statue.

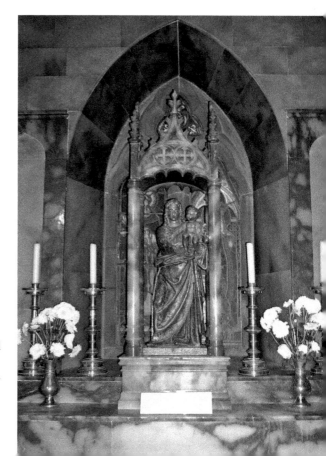

The statue of Our Lady of Brewood where the sword cuts from Civil War soldiers continue to seep water. (Author's collection)

Later, she was rescued and taken first to Chillington Hall, the home of the Gifford family, and then to Black Ladies, the Benedictine convent in Bishop's Wood where in James Hicks Smith's 1867 account of Black Ladies he wrote 'A ponderous little statue of the Blessed Virgin, carved in wood, continuing to occupy the place of the altarpiece'. Meanwhile, Thomas Gifford paid £486 for the land in Brewood on which the Catholic church of St Mary's was built. Designed by Augustus Welby Pugin, it was consecrated on 13 June 1844.

Today, the statue, known as 'Our Lady of Brewood', sits in a twentieth-century alabaster shrine above the Lady chapel in St Mary's and, regardless of the atmosphere, water still continues to seep.

Interestingly, the twelfth-century-style stone pillar stoup standing outside the church's south porch door is also reputed to have come from White Ladies nunnery.

St Mary's Catholic Church, Brewood, home to the statue of Our Lady of Brewood. (Author's collection)

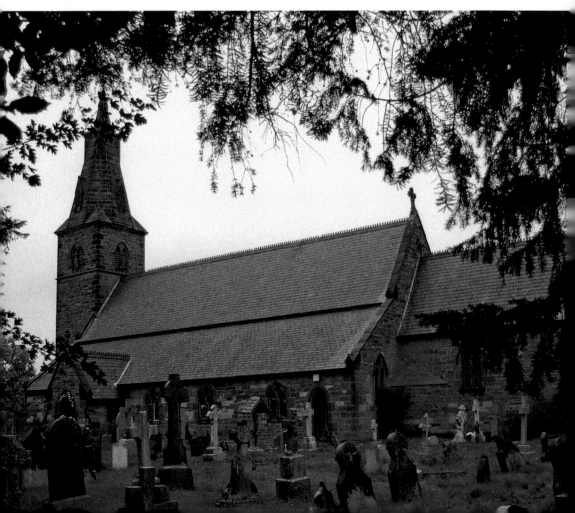

The Witch Mollie Leigh, Burslem

Margaret (Mollie) Leigh was born around 1685 and was apparently very ugly, a condition which grew worse as Mollie got older. Today it would be identified as a disability – though it was said that she chewed and swallowed a hard crust shortly after her birth.

Mollie spent her life in the dark, half-timbered Elizabethan cottage at Jackfield on Hamil Grange, the site of which is now occupied by Park Road School close to Port Vale's football ground. The cottage was split into two ground-floor sections, one a dairy containing a well and the second a living room, while above were two bedrooms. Following her parents' early death Mollie kept a herd of cows on Hamil Grange, making a living selling milk in Burslem town. As a result of her deformity, she was often ostracised, friendless and frustrated, which led her to have a quick and vindictive temper. There was a hawthorn bush next to the cottage on which Mollie's pet blackbird perched, and this bush never blossomed or bore fruit.

Rejected by the community, Mollie did not attend church and was declared a witch by the local rector, Parson Spencer, who spent a lot of his time at the Turk's Head inn. It is said that she instructed her blackbird to perch on the pub sign and so turned the beer sour and strangely, gave the drinkers rheumatism. When an angry Spencer fired his shotgun at the bird, which flew away, he felt the first pangs of a stomach pain that lasted for three weeks.

Mollie Leigh died in 1748 and was buried in St John's churchyard on 1 April, an unusually dark afternoon with heavy drizzle. When the mourners returned to her cottage via the Turk's Head, Parson Spencer was shocked to see Mollie sitting in her rocking chair by the fireplace knitting and mumbling 'Weight and measure sold I never, milk and water sold I ever.'

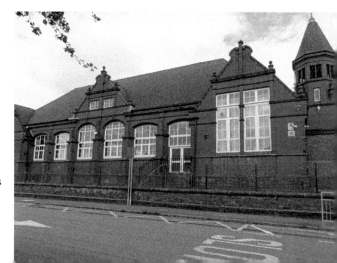

The Burslem school which now stands on the site of Mollie Leigh's cottage. (Author's collection)

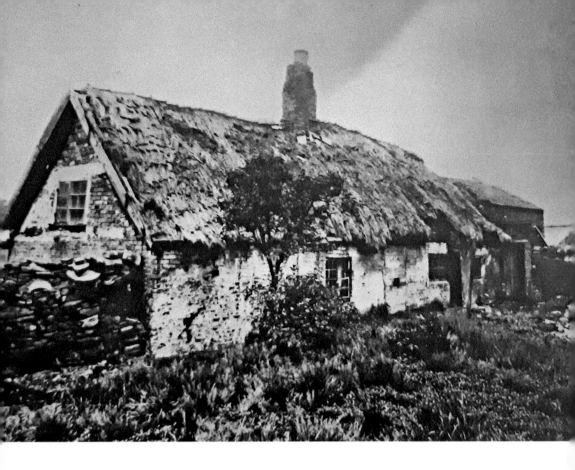

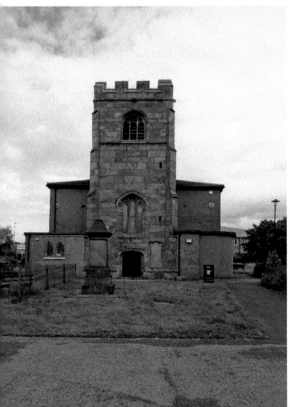

Above: Mollie Leigh's cottage.

Left: St John's Church, Burslem. Mollie Leigh is buried close to the church. (Author's collection)

At a later Sunday service, the rector declared that her spirit must be laid and duly contacted the vicars from Stoke, Wolstanton and Newchapel to assist him. The four clergymen, along with the sexton, met in the churchyard at midnight carrying candle lanterns, with one holding a cage containing Mollie's blackbird. It is said that the 'blackbird chirped dismally'. When her coffin was exhumed, the moon appeared from behind the clouds and the sexton, along with the other clergy, fled. Parson Spencer then opened the coffin lid and put the cage containing the live bird into the coffin before it was moved contrariwise to the other burials and the grave filled in. Some later claimed that she had been seen sitting on her own grave.

It is reputed that no one would go near Mollie's cottage, particularly after dark, and it remained empty until its demolition in 1894. For many years local children could be seen walking around her grave chanting 'Mollie Leigh, follow me, Mollie Leigh, follow me'.

Whatever the truth behind the story, Mollie Leigh's tomb can still be found facing in the opposite direction to the other graves in St John's churchyard, Burslem.

Mollie Leigh's tomb, which lies in the opposite direction to the other graves. (Author's collection)

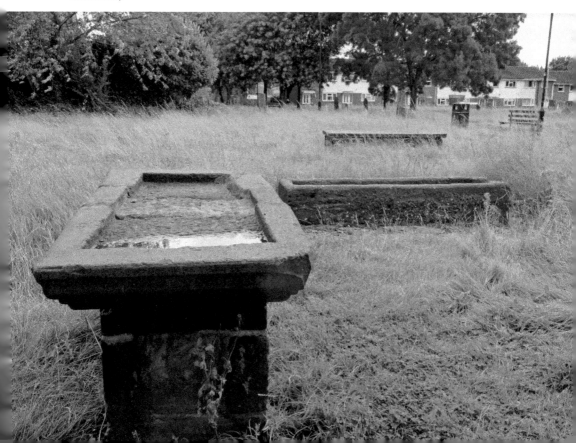

The Battle of Burton Bridge and the Tutbury Hoard, Burton-on-Trent

The Battle of Burton Bridge, 7–10 March 1322, was part of the Despenser War fought between King Edward II and his cousin Thomas Plantagenet, 2nd Earl of Lancaster from Tutbury Castle and not to be confused with the later Civil War battle of Burton Bridge that took place on 4 July 1643.

The bridge at Burton was of strategic importance being the sole crossing over the rivers Trent and Dove for travellers to and from the north country. Built of keuper sandstone, the medieval bridge was 500 yards long and 7 feet wide with thirty-six arches and was believed to have been built by Wulfric Spot, the benefactor and founder of Burton's Benedictine abbey *c.* 1002, though others put its construction later, at *c.* 1159.

What is known is that King Edward headed north to engage with Lancaster who, in an effort to thwart the King's progress, set about fortifying Burton Bridge and instructed John Mynors to break down the one at Wychnor. On 7 March 1322 the King arrived at Cauldwell planning to cross the little-known ford at Walton-on-Trent and outflank Lancaster. However, due to high flood water the King found himself delayed for three days, but sensibly he'd deployed a number of soldiers opposite Lancaster's men at Burton Bridge. The 10 March saw Edward's main army cross the river at Walton and from the direction of Branston they headed to the south side of Burton. Meanwhile, the Earl planned to confront the King in open battle but caught by surprise and realising that his 30,000-strong army was outnumbered, he set fire to most of Burton before fleeing over the River Dove and northwards. Amongst the casualties was Sir Roger d'Amory, the keeper of Alton Caste, who was wounded and died later of his injuries at Tutbury Castle. Lancaster was later defeated at the Battle of Boroughbridge and executed at Pontefract. As for Tutbury Castle, it was damaged and looted. Meanwhile legend has it that Robin Hood fought for Lancaster in the battle. Today, a new bridge stands at Burton, completed by 22 June 1864, shortly before the original Burton Bridge was demolished.

A strange superstition involving the wild indigenous Staffordshire cattle developed at the Chartley Estate home of 2nd Barron Ferrers. The herd dated back to 1225 when some parks were created on land formally protected by Forest Law which saw the cattle enclosed at Chartley. They were small, sand-white in

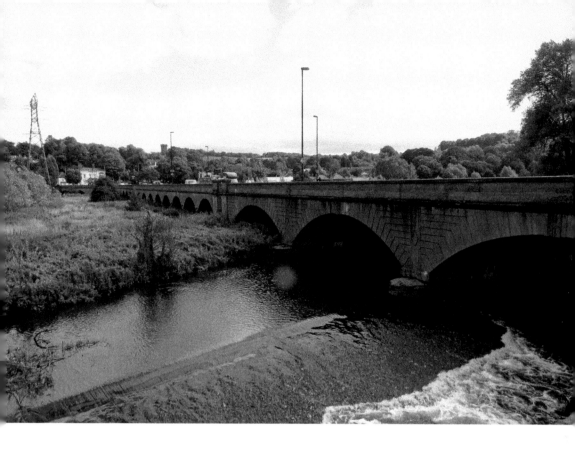

Above: The present Burton Bridge. (Author's collection)

Right: The Forest Charter Act under which the Chartley Estate was enclosed.

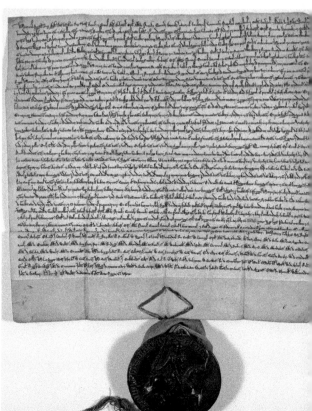

colour with black ears, muzzle hoof tips and a remarkably large tuft of curly hair on their foreheads, sometimes reaching to their eyes, which gave the appearance of a wig.

Following the defeat at Burton Bridge Barron Ferrers faced attainder of his goods when coincidently an unusual black calf was born to the Chartley herd at the time of the family's downfall. Throughout the generations, the birth of a black calf has proceeded a death in the family, occurring before the demise of Robert Shirley, 7th Barron and 1st Earl Ferrers, his wife and son Robert Sewallis Shirley and also, his wife and eldest son along with the daughter and wife of Washington Shirley, the 8th Earl Ferrers.

Some 500 years later, the Battle of Burton Bridge was in the news again. On 1 June 1831 workmen were improving the outfall of the cotton mill at Tutbury when they discovered some silver coins in the embankment of the River Dove and where further investigation led them to three small rotting barrels full of gold and silver coins. Valued today at over £250,000, it is the largest hoard of coins ever found in Britain with thirteenth- and fourteenth-century examples from England, Ireland, Scotland and mainland Europe – Bohemian, Polish and Flemish – during the reigns of King Henry III, Edward XXXX

The Tutbury Hoard was thought to have belonged to the Earl of Lancaster and is verified by a story that following the battle at Burton, the Earl hid his troop's pay chest in the River Dove beneath Tutbury Castle before heading north – probably in a hurry as some suggest that Lancaster may have been taking it to the priory for safe-keeping, but he never came back to retrieve it.

Word of the find spread quickly and Tutbury became Britain's 'silver rush town' with many coins looted before the authorities arrived. A statement dated 1851 reported that, 'Upon this discovery a general scramble commenced and numbers of people soon flocked to the place. Spades had never seen busier service.

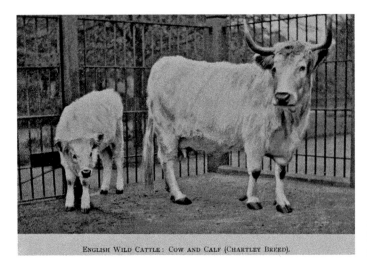

ENGLISH WILD CATTLE : COW AND CALF (CHARTLEY BREED).

A bull from the Chartley cattle herd.

Almost numberless coins, in close rows, came forth to the grateful sight of the more fortunate.' Apparently up to 300 men could be seen in the river at one time and indeed, two men seemingly picked up some 5,000 coins in one day. Of the 360,000 coins thought to have been discovered only around 100,000 were forwarded to the Crown. Today, most of the hoard is at the British Museum with a few coins on display at Stoke-on-Trent Hanley Museum. It is still forbidden to dig along the riverbank at Tutbury.

The mill wheels standing on the site of Tutbury mill. Nearby is where the hoard was discovered by workmen. (Author's collection)

The River Dove at Tutbury, close to where the hoard of coins was found. (Author's collection)

Statutes Fair, Burton-on-Trent

Burton Statutes Fair is the successor of a fair granted by charter in 1200 from King John to Abbot William Melbourne (1197–1213) to hold a fair on the eve, feast and morrow of St Modwen, 4–6 July, and a weekly Thursday market. During the time of the fair, it was not permitted for anyone else to sell goods in the town and all the regular shops were closed. This ensured the highest collection of tolls due to, in Burton's case, the Abbot.

Statute, Mops or hiring fairs probably began following the Black Death of 1348 when there was a scarcity of labour. Parliament attempted to regulate wages in 1351 by imposing fines on both employers or labourers who accepted more than a fixed wage. During the reign of Richard II (1377–99) Justices were required to meet once a year at 'Statute Sessions' to decide and proclaim the pay scale for each Hundred. These 'Statutes' became obsolete during the time of Queen Elizabeth I (1558–1603).

The Statutes Fair was primarily for farm labourers and servants to find work for the following year and where terms including board and lodgings would be agreed upon. Generally, they were held around September after the harvest had finished, though in North Staffordshire, Cheshire and Derbyshire hiring was often at Christmas, later moving to Martinmas or St Martin's Day, 11 November, in the east of the county, a feast associated with the gathering in of the harvest. Labourers would stand in rows wearing their best clothes and carrying items indicating their occupations, for example, wagoners, carters and ploughmen would hold a piece of whipcord; shepherds would hold a lock of wool; and cowmen a bit of cow hair.

Hiring fairs continued for longer in rural counties. In Staffordshire, the growing development of coal mining and manufacturing saw their decline; however, in Burton the 'Statutes' continued on the first Monday following Michaelmas. It was when the constables and householders met to hire servants, settle any disputes between employers and employees and decide upon a scale of wages. At the fair of 1890 young girls, depending on their experience, were paid up to £6.10s (£6.50p) annually while a trustworthy woman could earn up to £15. An experienced cowman may expect between £14 and £15.10s (£15.50p), less experienced men and youths up to £9.10s (£9.50p) and lads between £6 to £8.

The Statutes had been criticised as early as 1824 and in 1889 it was seen as a 'human flesh market' while in 1892 critics accused the fair of 'encouraging drunkenness and immorality' with the pleasure fair causing an obstruction in the streets. By 1942 the country parishes had organised and sent a petition to Burton

Town Council. Even after several failed attempts to abolish it the hiring aspect of the fair continued until 1926, though with reduced business following the 1910 opening of the labour exchange.

Today the Burton Statutes Fair is held on the first Monday and Tuesday following Michaelmas, usually beginning on the first Monday in October in the market place and nearby streets. The fair is operated by Pat Collins Funfairs who have a long association with Burton over the last 100 years.

Well Dressing, Endon

The ancient custom of well dressing, when special tributes were paid to wells, springs and fountains, was traditionally held on Ascension Day, forty days after Easter and ten days before Whitsun. However, Mr G. T. Lawley, writing in the nineteenth century, talks of two 'Well Wakes' in North Staffordshire held at Whitsun. He wrote of one held at Milton in 1884 'When the New Well was beautifully decorated with green boughs and bright flowers' and a similar event at Endon 'Where the principal Well had been specially decorated for the occasion'.

The art of dressing wells and springs with pictures made from only natural materials is to be found mostly in Derbyshire – Tissington is one example – with a few exceptions in North Staffordshire where the blessing of a clean water supply dates back to the Celts or perhaps even earlier.

As for Endon, the first ceremony was a simple one held at Old Smithy Bank on 29 May for Oak Apple Day 1845 in thanksgiving for the new well built by Mr Thomas Heaton which bought pure-quality water to the village and was subsequently presented to the villagers. It is said that throughout a prolonged drought the well continued to flow, suppling the village with water. By 1852 it had become an annual event and 300 people attended, beginning with an afternoon procession to St Luke's' Church followed by a visit to the decorated well before afternoon tea and then dancing in Jaw Bone Field to the east of the Methodist chapel for which there was an admittance charge of one-shilling (5p). Four years later an organising committee was formed and in 1864 the Endon Brass Band was invited to play. So popular was the event that by 1872 the festivities were held over two days with maypole dancing and the crowning of the May Queen. In 1916 it went on to be held over Whit Weekend before in 1991 moving to its present date of the Spring Bank Holiday.

The custom of distributing any profits began in 1860 when some £25 was shared amongst the poor on St Thomas' Day, 21 December. Later, as the well dressing grew some money was also given to the Church of England Sunday school, the Wesleyan Methodist Sunday School and the Free Grammar School (Endon Parochial School). More recently the committee bought the field used for the celebration at a cost of £80,000 and now that the money has been repaid, all the proceeds go to local charities.

A week prior to the event clay is pressed into boards and then a pointer used to trace the selected picture onto the clay. It takes many hours of work to infill the picture with flower petals and other natural materials. Where every petal is attached separately to overlap the next one, as tiles on a roof would be, rainwater – if the weather is inclement – can run off the picture.

At Endon, there are three wells to be dressed. The large dressing is placed at the fountain on the junction of The Village and Brook Lane while three schools' dressings are placed alongside. Diagonally opposite is a house where a very small dressing is placed in the garden and at the opposite end of the village is another small well at Graton Lane.

In the field, local men compete in 'Tossing the Sheaf', a competition in which a bale of straw is tossed over a raised bar – the highest wins.

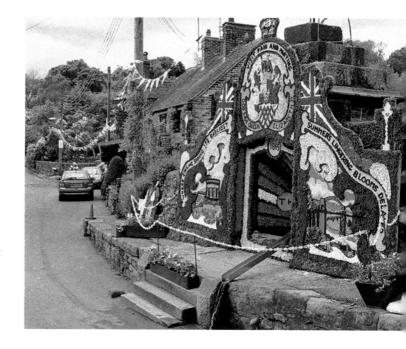

The well dressing at Graton Lane Well on the junction of The Village with Brook Lane. (Photo Alan Gibson)

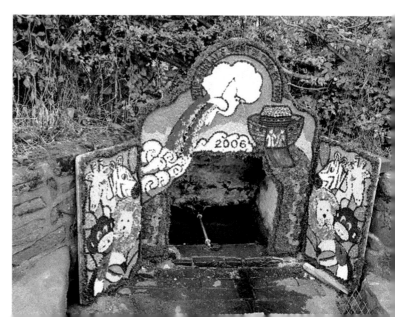

The small well dressing diagonally opposite the fountain.

The following is poem to mark the twenty-fourth celebration in 1869 by Thomas Heaton:

Endon fair spot! Whose varied scene,
Of woodland, hill and dell,
Of mill and stream, and meadow green
Enchants us with a spell?
Where balmy airs, pure as is springs,
Shed health and vigour from their wings,
And rose bloom on maiden's cheek:
Where rustic youth and beauty dwell
And hoary looks crown faces sleek,
And tinged with heather-bell;
But other themes the muse bespeak,
Of Endon's famous well.

O Endon Well! Fair Endon Well!
Where deep in mountain cavern, and
Cradled in rocky bed, or sand
Thy birthplace who may tell?
Who may divine thy talent source?
May trace thy mazy upward course,
Uncurbed by each obstructive check;
Until the mind in matter pent,
Bursting its clayey temperament,
Or struggling truth through errors night,
Joining the kindred element,
Emergest clear into the light?
Thou sparkling Endon Well!

O Endon Well! Prolific well!
When tropic suns and Summer drought
Make other sister springs go dry,
And Heaven, whose ways non may find out,
Withholds the treasures of the sky; -
To slake the thirst of man and beast,
Unstinted still in thy supply
Of Aqua Pura – coolest best
Then thanks to Him whose care benign,
Gathered thy treasures to this spot;
And reared to thee this splendid shrine
His name shall never be forgot; -
Nor thine, - thou blessed well.

O Endon Well! Fair Endon Well!
Bedecked in holiday attire,
Festooned with floral chaplets fair,
For natures lovers to admire;
And blazoned with devices rare,
Of lettered phase and holy writ;
Quaint hierogram, and symbol lore,
For thy anniversary fit,
Then let us drain a bumper full
Of thine own beverage today,
In grateful homage to thy name;
And hail thee, - the Lymph Queen of May,
Thou far – famed Endon Well.

O Endon Well! Pellucid well;
Meet founts for naiads chaste to love,
Their virgin limbs and tresses sheen,
Spangled with liquid gem; - and have
The nymph, fair undine for their Queen;
To thee their court, while hundreds pay,
On this, thy joyous festal day;
The muse would offer on thy shrine,
Her simple tributary lay;
And thank in song the power benign,
That bade thy ceaseless waters flow
For us, His creatures here below; -
Thou precious Endon Well.

Explosion, Fauld

In late 1944, Joseph Goebbels announced that the explosion at RAF Fauld was the result of a V2 rocket strike. This was propaganda.

Fauld gypsum and alabaster mine dated back to the eighteenth century when it was one of three drift mines dug almost horizontally into the hillside leading to 180,000 square feet of tunnels 12 feet high and 20 feet wide lying 90 feet under the surface directly below Upper Castle Hayes Farm. In 1941 this vast subterranean tunnel network was requisitioned by the RAF for use as an underground munitions storage depot where it was filled to the roof with many thousands of huge bombs all stored some distance from the roadways. Each month RAF Fauld would receive and distribute 20,000 tons of bombs along with 6-inch Howitzer shells and rifle rounds. This was all managed by eighteen RAF officers, 475 other ranks, 445 civilian workers and 195 Italian prisoners of war who were inexperienced with handling high explosives.

Monday 27 November 1944 dawned a beautiful frosty and cloudless morning where some residents of nearby Hanbury village were busy decorating and preparing the village hall for a dance that evening. At 11.11 a.m. 4,000 tons of weaponry exploded: high-explosive bombs and other weapons with some 500 million rifle rounds. The resulting crater was 300 feet (91 m) by 250 yards across (230 m) with a depth of 130 feet (30 m). Eyewitnesses spoke of seeing two distinct columns of black smoke several thousand feet high in the form of a mushroom cloud with a fire at the base. Upper Castle Hayes Farm was blasted half a mile skywards killing six people and 200 cattle. Nearby, a reservoir containing 450,000 cubic metres of water was destroyed, adding to the chaos. A combination of glutinous mud, rocks, trees and buildings slid into Messrs Peter Ford's lime and gypsum works killing all thirty-three people inside while demolishing Purse cottages. As for Mrs Ida Hellaby, her home, Fauld House, lay behind a hill and was somewhat protected from the direct explosion and deafening noise. The sunny morning had turned completely black as water, soil and debris cascaded down over an area of 1,420 yards (1,300 m). Ida thought the Day of Judgement had come.

One witness said, 'There was a blinding flash and the ground I was standing on shook beneath my feet and lumps of clay, the size of railway engines soared into the sky.' Then rocks, parts of buildings and trees crashed back down to earth, some as far as 10 km away. In Tutbury, 3 miles distant, villagers watched as mature trees rained down like matchsticks.

The present Hanbury Memorial Hall – the original was destroyed in the Fauld explosion. (Author's collection)

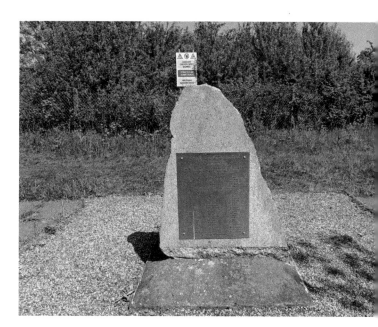

The monument to those killed in the Fauld explosion. (Author's collection)

When William Beck's train – he had been an engine driver for thirty-eight years – was stopped at Scropton Sidings 2 miles west of Tutbury for ten minutes he didn't realise the delay would save his life. William's train should have been at Fauld when the mine exploded. Meanwhile, the school headmistress, Miss E. M. Fardon, instructed the children to hide under their desks as stones, mud and debris continued to fall through the roof for over four minutes. Fortunately, none of the children were hurt. The school was to remain closed until 18 December as it became a temporary mortuary. As for Hanbury village Hall, it was blasted into the adjoining field.

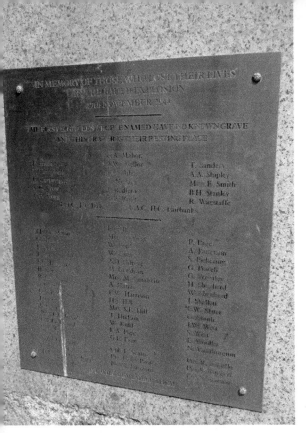

Close-up of the plaque on the Fauld Memorial. (Author's collection)

What caused the explosion has never been proved. The base was known to be short staffed and one theory proposed was that a site worker removed the detonator from a live bomb with a brass chisel instead of a wooden batten. Others thought it was sabotage by an Italian prisoner of war who failed to defuse a bomb sent back from an RAF station. However, in 1994 Malcom Kidd, who was a young aircraftsman at RAF Fauld, remembered that before the explosion he had to deal with two 1,000-lb bombs left behind after an RAF bomber crash. Following his sergeant's orders Malcom stencilled the legend 'For dumping in deep water' on each bomb as they were to be jettisoned over the sea. 'The RAF were fully trained and did things by the book' he explained. 'But the civilians were a law unto themselves.' Sitting in the restroom, a civilian worker thought differently: 'I will get some stillsons (a large wrench), take the noses off those crash bombs, and we can send them out again.' Malcom was sure that the worker's attempts to unscrew the nose-pistol of one of the 1,000-lb bombs had caused the explosion. For years he had lived with the guilt of not saying anything but he was young and of junior rank, taught to obey without question. Another story tells of an armourer who discovered a damaged exploder on a 450-kg bomb stored alongside a number of similar ones but used the wrong tool in attempting to remove the exploder. The bomb exploded and the resultant rush of air detonated the neighbouring pile.

In the surrounding villages and hamlets miners trained in rescue work assisted by RAF personnel, US troops and Italian PoWs searched for survivors, but for many of the missing there would be no funeral or burial. It took a year for the thousands of tons of weaponry that was accessible to be removed and today there is still some 3,000 tons of unexploded bombs in the collapsed mine tunnels.

Whatever the cause, thirty years later the official enquiry ruled it was due to a failure of supervision and safety precautions.

Fauld continued to operate until 1996 when No. 21 Maintenance Unit (21 MU) was disbanded. It was taken over by the US Army in 1967 to store their armaments before finally closing in 1973.

More tragedy was to follow as later the same November day a bus travelling from Derby to Hanbury bringing local war workers home crashed leaving one passenger from the village dead and three more injured.

Fauld was Britain's largest ever explosion, the world's greatest accidental one and one of the biggest non-nuclear explosions in history, shattering windows some 40 miles away – the blast was heard in London and it registered on seismographs throughout Europe as far as Switzerland.

In 1990 a memorial was donated by the munitions depot in Novara, Italy, the sister depot to RAF Fauld and at the time also RAF Stafford, made from fine white biotite granite probably from Sardinia.

Panel telling the story of the Fauld explosion at the memorial site. (Author's collection)

THE FAULD EXPLOSION

At just after 1100 hours on the 27th NOVEMBER 1944, the largest explosion caused by conventional weapons in both the world wars took place at this spot when some 3,500 tons of high explosives accidently blew up.
A crater some 300 feet deep and approximately a quarter of a mile in diameter was blown into the North Staffordshire countryside.
A total of seventy people lost their lives, with eighteen bodies never being recovered.
The 21 MU RAF Fauld disaster is commemorated by this memorial which was dedicated on the 25th November 1990, some 46 years after the event. The stone, which is of fine white granite, was a gift, organised by the Commandante of the Italian Air Force Supply Depot at Novara, a sister depot of No 16 MU RAF Stafford, from the firm of CIRLA & Son, Graniti-Milano.

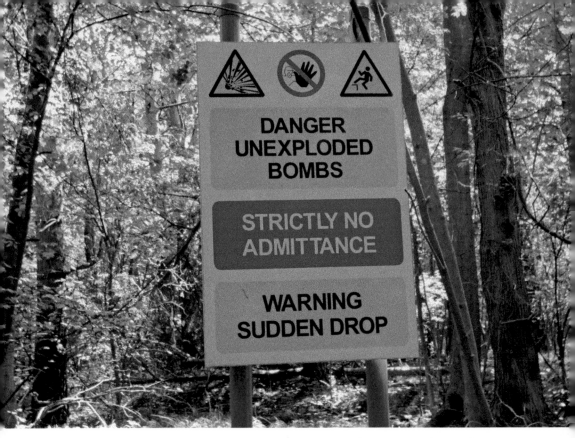

Above: A warning sign of unexploded bombs on the top of the crater. (Author's collection)

Below: The graves in Tutbury churchyard of some of those killed as a result of the Fauld explosion. (Author's collection)

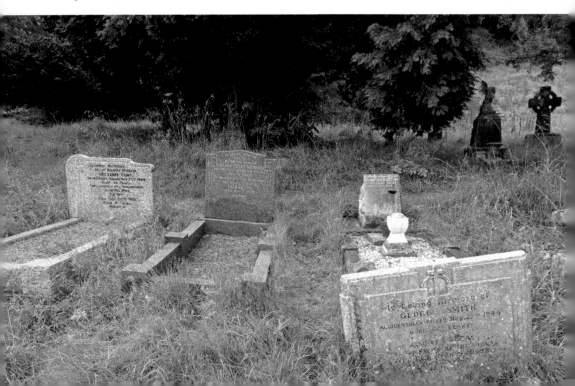

Teapot Parade, Flash

Some 250 years ago the thrifty women of Flash would save pennies in a teapot for a rainy day. Living in the highest village in England 1,518 feet above sea level, it was also known as a camp for 'badgers' or hawkers who lived on the open land surrounding the village making a living travelling from fair to fair. The term 'Flashman' to describe a pedlar was in use in 1766. The village's close proximity to three county boundaries – Staffordshire, Cheshire and Derbyshire – made it an ideal location for nefarious activities like illegal prize fighting. It was easy to avoid the local law by fleeing to the next county. Moreover, Flash had a somewhat dubious claim to fame as, due to being isolated on the moors, it became known for counterfeiting money – hence the term 'Flash money'. This was the main theme of Judge Alfred Ruegg's historical romance *Flash* published in 1928. Whether his book had some basis in fact or whether the counterfeiting was a figment of his imagination is open to interpretation.

With no outside help or local charities for those who found themselves in need, each family would donate regularly to a fund collected in a teapot. Then, if anyone became sick or had to pay for a funeral the teapot would be emptied on the kitchen table and the money doled out before the collection would start again. The fund dated back to at least 1767 when it is first mentioned as the Quarnford Club (the parish which encompasses Flash). Later, in 1846 the Flash Loyal Union Friendly Society was founded at the Traveller's Rest pub and by 1906 it was known as the Teapot Club. At its peak, there were 700 members.

The giant papier mache teapot on the Flash Teapot Parade. (Photo Ross Parish, Pixyled Publications)

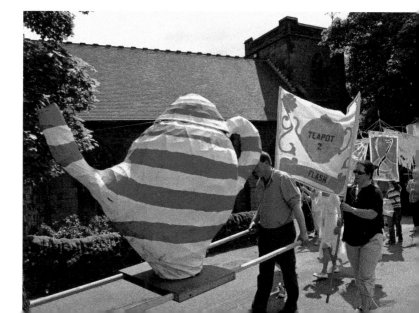

Doug Pickford in his book *Earth Mysteries of the Three Shires* considered it strange that such an isolated village would possess a teapot in the middle of the eighteenth century when tea drinking was the preserve of the better off. One interesting theory he suggested was that the name could be much older, from the Celtic Taoiseach – pronounced tea shock – leader.

A requirement of the Teapot Club was that all members should attend an annual church service and parade or pay a fine. Carrying banners, the parade was led by a band form either the parish church of St Paul's or the Methodist chapel – on alternate years – to the Traveller's Rest pub and then back to the village hall for tea.

However, by 1995 new laws regarding saving organisations meant that it would be unlawful for unregulated clubs to collect small sums of money. This was the last authentic parade of the Flash Loyal Union Friendly Society, when the banner was laid over the church door and the society finally dissolved.

The traditional parade, though, continued the following year with the inclusion of a giant papier-mache teapot. In 2006 a well dressing – this is the Peak District – was included and the Flash Rose Queen with her retinue joined the procession. The parade is still an important event in the village calendar, with photos dating back to the 1800s.

Musicians at the head of the Teapot Parade. (Photo Ross Parish, Pixyled Publications)

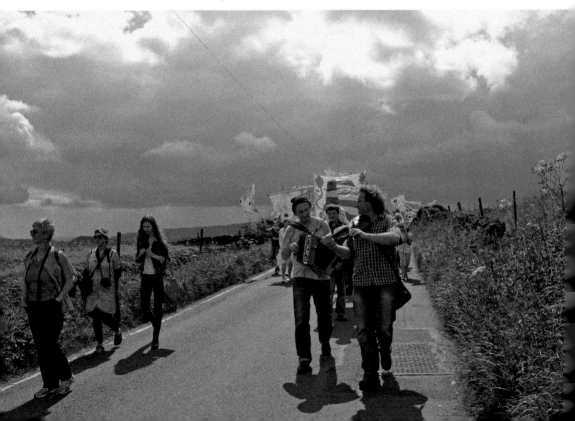

Above: The well dressing at Flash which is part of the celebrations and incorporates the teapot. (Photo Ross Parish, Pixyled Publications)

Below: The Traveller's Rest Inn incorporating The Knights Table at Flash, the destination of the Teapot Parade. (Author's collection)

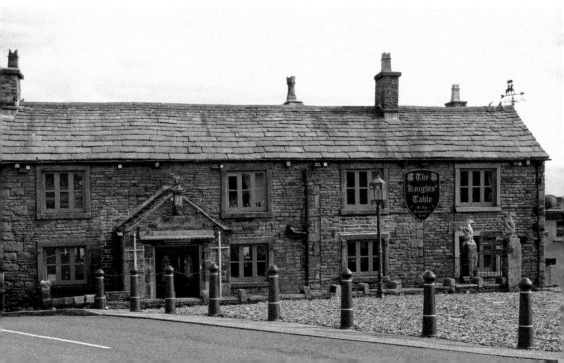

Hedgehog Rolling Festival, Grindon

Each summer on a Sunday in early July the village of Grindon holds a unique festival, the history and origins of which are lost in the past; however, the tradition of hedgehog rolling must be one of Staffordshire's strangest customs.

In the moorlands hedgehogs were often kept as a sort of pet, useful for their ability to control pests such as slugs, snails, etc., which in turn enabled more food to be grown. Meanwhile, villagers would train some of these to compete in hedgehog racing with the use of an ultrasonic whistle – similar to a dog whistle.

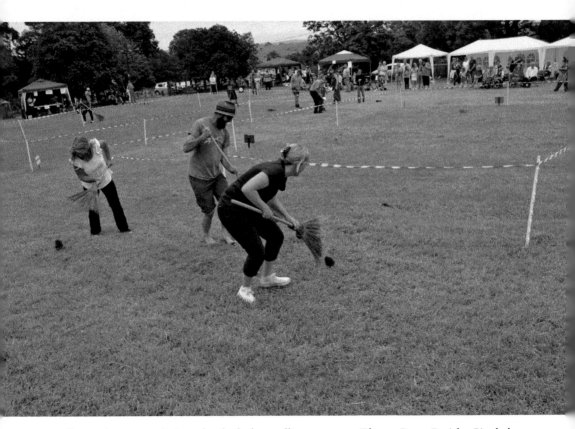

Competitors negotiating the hedgehog-rolling course. (Photo Ross Parish, Pixyled Publications)

One signal would teach the hog to roll up for the downhill parts of the course while another would tell them to unroll for the uphill sections.

It is believed that after the author Lewis Carroll visited Grindon on Hedgehog Rolling Day it inspired him to write the flamingo and hedgehog croquet game in his book *Alice in Wonderland*.

For some reason – no one is sure why – the tradition was discontinued in the early years of last century, maybe in part because of the onset of the First World War. However, in 2002 Grindon Action Group committee revived the event to raise funds for village projects. Animal lovers though need not be worried. Today the hogs are giant fir-cones from France decorated in the fashion of hedgehogs while 'rovers' bearing besoms brush them around the village racecourse. Each cone has a name beginning with the letter H – Harriet, Henry, etc. – and competitors are allowed to choose their cone with the understanding that it's returned to the registration tent afterwards. Locals make the racing look easier than it is. A cone that is too heavy or large can be difficult to control while a broom with a head too long can create too much force.

Elsewhere the hosts Black Dog Molly Dancers perform along with other invited dancers. Traditional stalls sell refreshments, host a tombola and other games alongside a village tug-of-war, all the proceeds of which go to local enterprises.

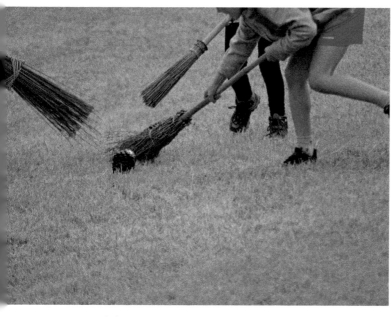

Above left: Sweeping the 'hedgehogs' at Grindon hedgehog rolling. (Photo Ross Parish Pixyled Publications)

Above right: Besson broom and fir cone 'hedgehog'. (Photo Ross Parish, Pixyled Publications)

Above: Grindon 'hedgehog' cones with their name tags. (Photo Ross Parish, Pixyled Publications)

Below: Start of the race with Besson brooms and 'hedgehogs' at the ready. (Photo Ross Parish, Pixyled Publications)

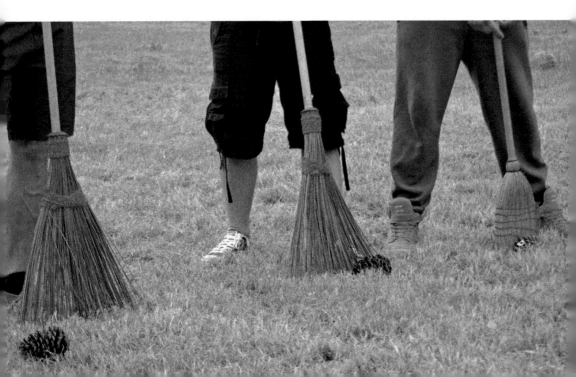

Air Crash, Grindon Moor

The winter of 1946/7 saw some of the heaviest snowfall ever recorded in England and although the people of the Staffordshire Moorlands witnessed a gentle thaw in January, experience taught them that there was more to come. By February all the roads had become impassable and villages were cut off. Bread, flour and fats were in short supply for around 3,000 villagers, though milk was plentiful, as the lorries were unable to reach the farms. Alerted to their plight, the Ministry of Food contacted RAF Fairford in Gloucestershire to parachute supplies in for the stranded communities.

By 11 February, the villagers of Longnor had been living on potatoes and milk for two weeks when No. 47 Squadron was put on alert. Food delivered to RAF Fairford was packed into containers and loaded onto ten aircraft. Meanwhile the inhabitants of Butterton and Longnor were instructed to mark the drop zone with a huge cross of soot on the snow. Early on the morning of the 12th a Halifax with the Commander of 'A' Flight plus crew and another officer in a Vultee Vengeance set off for a reconnaissance flight over the target. The weather, though, was found to be extreme with cloud as low as 300 feet. Even so, the Halifax made two practice runs and managed to drop their cargo of 20,000 lbs worth of food on the third fly past while the Vengeance had already left for home. At Fairford all other relief flights were cancelled that day.

The following morning eleven crews were briefed before take-off. The weather was reported as 'granular drizzle' with cloud covering the hilltops and visibility down to less than a mile. When the Handley Page Halifax A Mark 9 RT922 took off it had already flown some 75,000 wartime sorties and dropped around a quarter of a million tons of bombs. Later, it had become a transport aircraft

A Halifax bomber aircraft similar to the one that crashed on Grindon Moor.

bringing home former prisoners of war, the wounded and those heading back for demobilisation ahead of conversion to a freight carrier.

At 08.45 a.m. the aircraft left Fairford to arrive over the moorlands at approximately 09.50 a.m. where it made its first run but failed to see the drop zone near the top of Grindon Moor as the cloud base was down to 100 feet. The pilot Squadron Leader Donald McIntyre's crew, who managed the navigation and radio, included Flight Lieutenant Ernest Smith, two Warrant Officers – Richard Sydney Kearno and Victor Chapman – and Flight Sergeant Kenneth Charles Pettitt. The crew also included ex-Army glider pilot William Sherry, a hero of Arnhem, who was on board as an observer, plus two press photographers, Joseph Gordon Rearden and David William Savill. They radioed to say they were making a second attempt. Ten minutes later another message reported that they were unable to find the village and would try a third time as conditions over the drop zone were 'worse than yesterday'. It was either during the run out from the second or whilst making the third attempt to find Butterton that the aircraft's starboard wing tip struck the 1,000-foot-high hilltop, the highest point on Grindon Moor, resulting in the Halifax cart wheeling across the road and over fields on the south-western side of the ridge. The fuselage split in two as the fuel exploded just above the ground, and smashed food containers scattered their contents in the snow. Of the crew, local rescuers with axes who had converged at nearby Sheldon Farm managed to free the only one alive – one of the photographers who died shortly afterwards. Assisting in the rescue was Mr Strasser, a photographer from Newcastle hoping to capture the drop but unfortunately, he was to have a very different story to tell. By 11 a.m. the National Fire Service had been alerted but, hampered by 16-foot-high snow drifts, it was 4 p.m. before they were able to reach the crash site to find that by then the villagers had removed the bodies and wrapped them in the sacking from the food containers.

Ironically, the locals found out later that the road from Leek had been opened that day enabling supplies to reach them by road and no more flights needed to be sent. The RAF crews on standby at Fairford were stood down.

The rescue team spent the night in the neighbourhood of Grindon waiting for the next morning when the roads became clear enough to allow vehicles to pass. The bodies were initially taken to Leek, then five days later to Harpur Hill near

The memorial to the air crash at Grindon Moor. (Author's collection)

Buxton, then the home of RAF Maintenance Unit 28 and the Peak District RAF Mountain Rescue Team.

With hindsight whether the flights were ever really necessary still remains controversial; however, those who died will not be forgotten as a memorial to them at the crash site close to Sheldon Farm was unveiled on 28 September 1999.

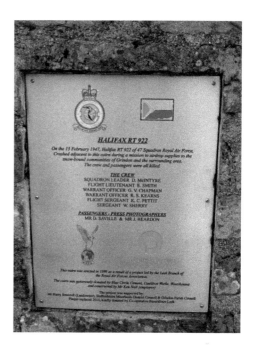

Right: Close-up of the plaque on the memorial cairn at the Grindon Moor crash site. (Author's collection)

Below: The gateway to Sheldon Farm where the rescuers co-ordinated their operation. (Author's collection)

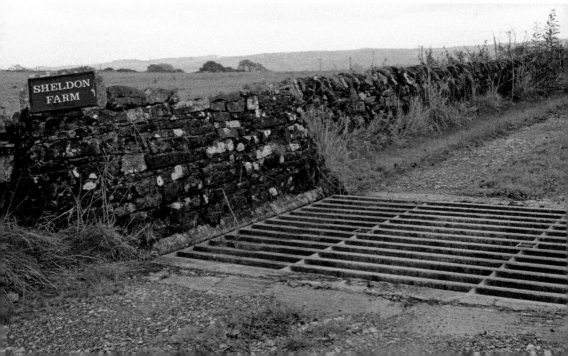

Staffordshire Hoard, Hammerwich

On 5 July 2009 metal detectorist Terry Herbert was searching a field close to Hammerwich owned by Fred Johnson when he discovered a piece of gold. Over the next five days, he went on to unearth the largest hoard of Anglo-Saxon gold and silver metalwork ever to be found.

Dating back to around the sixth or seventh century, there are over 3,500 items with a combined weight of 11 lbs (5.1 kg) of gold and 3lbs (1.4 kg) of silver with 3,500 pieces of garnet cloisonné jewellery. Initially the find was kept secret to deter bounty hunters and only when it was clear there was nothing more to be found was the true extent of it announced publicly on 24 September.

There has been a lot of speculation about the hoard. Maybe it was plunder buried by a king of Mercia or warlord from a raid on the other Anglo-Saxon kingdoms – Wessex, Northumberland or East Anglia. Or perhaps it was buried by the owner in fear of an imminent attack. Whatever the reason, the workmanship is of such high quality that it surely belonged to either Anglo-Saxon kings, princes, members of their royal households or warrior retainers. Nearly all of the pieces apart from two or three Christian crosses are military; there is no jewellery commonly associated with women or any domestic items – plates, goblets eating utensils, etc. Twenty-eight of the pieces have garnets, which may have originated in Sri Lanka or Afghanistan in the Roman period and many have Christian and pagan symbols. The larger cross, which was discovered folded, may have been a processional or altar cross while the second, smaller one may have been a pectoral cross. One item in particular is a small gold strip measuring 179 mm X 15.8 mm X 2.1 mm and carries a Latin Biblical inscription from the Book of Numbers 10.35 or Psalm 68: 'Surge Domine et disspentur imimici tui et fugiant quioderunt te e facie tua', which translates as 'Let God rise up, let His enemies be scattered; Let those who hate Him flee before Him'.

The verse is quoted in the 'Life' of Mercian Saint Guthlac and appears in the meeting of Guthlac with the later King of Mercia, AEthelbald.

Other interesting and rare objects are a high-status Anglo-Saxon helmet and a gold sword hilt inlaid with cloisonné garnet.

Under the Treasure Act of 1996, the collection was purchased jointly by Stoke-on-Trent museum and art gallery in Hanley and Birmingham museum and art gallery.

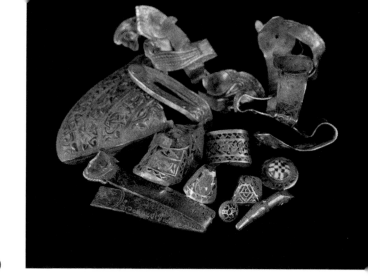

The Latin-inscribed folded gold band amongst other items. (Photo David Rowan)

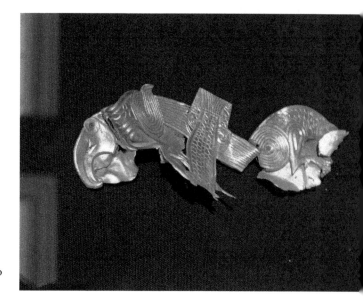

The sheet gold plaque. (Photo Jon Callas)

The Ilam Pan, discovered in June 2003 and considered to be a Roman soldier's souvenir of Hadrian's Wall.

Another find of great national and international importance was discovered earlier in June 2003. The Staffordshire Moorlands Pan, also known as the Ilam Pan, was found by metal detectorists within the parish. Dating from the second century AD, the bronze – or more accurately copper alloy trulla – is inscribed with the names of four of the forts from the western end of Hadrian's Wall.

From its inception in AD 122 Hadrian's Wall was Roman Britain's northern defensive boundary and must have impressed the many soldiers who were garrisoned there; to the extent that they commissioned souvenirs of their time spent on the Empire's frontier, the best surviving example of which is the Ilam Pan.

Initially used for cooking and serving food, it would have had a flat handle and a base, both of which are missing, and is decorated in a Celtic style – Roman period Celts produced more enamel on metalwork than others across the Empire. Dating from AD 100–199, it weighs 132.5 g and stands 47 mm high with a maximum diameter of 94 mm and the outside of the base measures 54 mm. Around the rim are the names of forts from the Solway flatlands west of Carlisle to the Pennines. MAIS (Bowness on Solway), COGGABATA (Drumburgh), VXELODUNUM (Stanwix), CAMMOGLANNA (Castlesteads) followed by RIGORE VALI AELI DRACONIS, 'on the line of the Wall of Aelius'. Draco was perhaps a soldier and owner of the pan while VALI alludes to the Wall. AELI too could be part of his name but it was also the family name of Hadrian, which explains why the Romans would refer to the Wall as 'AELIAN WALL'.

Below the inscription the colourful and swirling polychrome enamel inlay circles decoration is reminiscent of Iron Age artwork. The technique's origins lie in northern Europe and were a favourite of military personnel. How it became lost in the Staffordshire Moorlands remains a mystery.

In 2005 the pan was purchased jointly by the Tullie House Museum, Carlisle, the Potteries Museum, Hanley, and the British Museum. It is on rotational display between these three sights.

Gold sword hilt fitting with garnet inlay. (Photo Daniel Buxton)

Crooked House Pub, Himley

Close to the South Staffordshire border near Himley is one of the most famous and unusual pubs in Britain, if not the world. Hidden away at the end of a narrow winding lane, the Crooked House was originally built in 1765 as a farmhouse and became a pub *c.* 1830 to serve the local farm workers and coal miners. It was originally called The Glynne Arms after the landowner, Sir Stephen Glynne, on whose Oak Farm Estate it was built. Incidentally Sir Stephen was the brother-in-law of Liberal MP William Gladstone.

Sitting adjacent to Glynne's estate and the pub was the Earl of Dudley's land from which the Earl was extracting coal. Sometime in the middle of the nineteenth century, the miners inadvertently tunnelled through the border onto Glynne's land and under the pub. As a result, one side of the building subsided 4 feet into

The Crooked House Pub at Himley. (Author's collection)

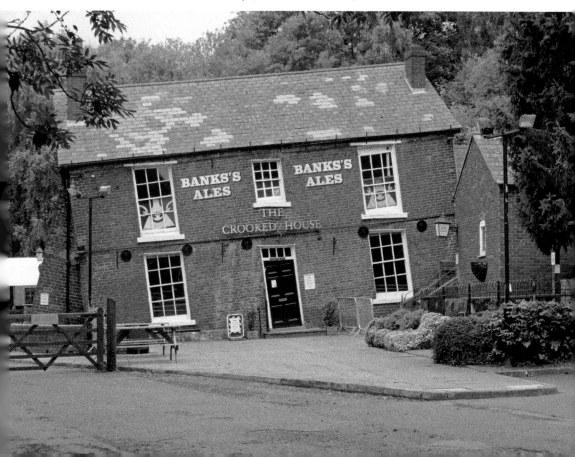

the mine workings, causing the walls to tilt at an angle of 16 degrees, four times that of the Leaning Tower of Pisa. Whilst most buildings would have collapsed, it survived with the help of supporting buttresses. It was given the colloquial name of 'Siden House' or 'Sidin' (Side on) – crooked in local dialect.

Shortly after the end of the Second World War, The Glynne Arms or Crooked House was closed, condemned and set for demolition. However, it was saved by Wolverhampton and Dudley Breweries who strengthened the buttresses on the south side. Then in 1952 it was proposed that the old, heavy tiled roof be removed and replaced with a lighter 'umbrella' roof supported on hidden stanchions to take the weight off the walls.

Once inside, walking across the floor is similar to being on a ship at sea where the level floor and leaning walls create some very strange optical illusions; for example, glasses will slide over apparently flat tables and coins travel up as oppose to down the bar. Visitors are amazed to see the gravity-defining marble roll up backwards along the dado rail. Furniture too has had to be adapted as a grandfather clock placed next to the wall at the bottom can be several inches away at the top.

A building of that age would not be without its ghosts. One is believed to be a former landlord, a man of short stature in his sixties to seventies who comes into the bar and then disappears before ordering a drink. Another apparent apparition is a girl dressed as a parlour maid and known as Polly. She has been seen around the old fireplace and may have worked there when the pub was a farmhouse.

The pub has been a tourist attraction since the nineteenth century and has a local rhyme associated with it:

> Come in and have some home brewed ale,
> And stop as long as you are able,
> At a pub they call the Sidon House,
> Where the beer runs up the table.

Rock Houses, Kinver

Kinver Edge has been inhabited from at least 200 BC. Here were two Iron Age forts. One, Edge Hill Fort, occupied the northern end of the ridge, and a second fort sat at Drakelow Hill to the south. The former was believed to have been used by Roman soldiers *c*. AD 60. The Edge is also the site of the last troglodyte – cave dwellers' – houses to be occupied in England where there is a set of complete cave dwellings hewn into the soft sandstone.

Some of the oldest caves dug out of the rocks at Kinver Edge are thought to have been made as early as AD 700 and appear to equate with the arrival of Christianity in the region in AD 600–700. An entry in the Domesday Book records people living there. Meanwhile, one rock named 'Holy Austin' was a hermitage prior to the sixteenth-century Reformation. Likewise, in neighbouring Shropshire similar caves have been discovered in Bridgnorth dating from AD 790 and in Nesscliffe from AD 1490, probably of religious significance.

One rock, Nanny's Rock, known as 'Meg-o-Fox-Hole', is a large cave made up of five sections that was never converted into a habitable dwelling. The Kinver parish register of 8 June 1617 records the death of 'Margaret of the Fox Earth', so possibly she lived there. The cave became the base for a notorious gang of robbers in the early nineteenth century where it was said that a passage led to a further set of cave dwellings a mile away. There are no traces of a passage now.

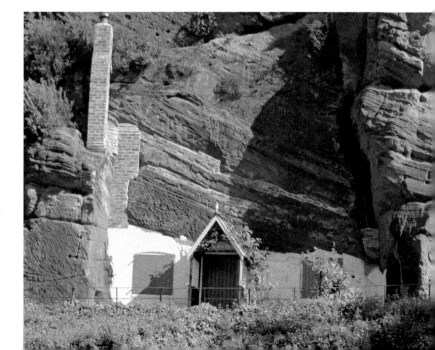

A Kinver Edge Rock House carved from the sandstone cliff. (Author's collection)

The eleven houses that can still be seen sit on three levels and were excavated around 1770 as a means of providing cheap accommodation for employees of the Hyde Iron Works. They comprised of a living room, bedroom and a storeroom for food in the furthest and coolest part of the cave, and despite having no running water – that came from a well – and a communal privy, the houses were warm in winter and cool in summer. If a resident needed more space it was a simple matter of digging further into the soft sandstone to expand the house.

In 1777 Joseph Healy was the first to write of the Rock Houses in his book *Letters on the Beauty of Hagley, Enville and the Leasowes with Critical Remarks and Observations on the Modern Taste in Gardening*. He wrote of them as 'Curious, warm and commodious and the garden extremely pretty'.

The National Trust was presented with 190 acres of Kinver Edge in 1917 by the four children of Kinver-born Birmingham solicitor Robert Grosvenor Lee as a memorial to him and his wife. Although around this time a lot of the families had begun to leave the Rock Houses, one family, the Shaws, had lived at Holy Austin Rock for over 150 years when they left at the outbreak of the Second World War. The reason may have been because of increased worries over safety, as a report on Wednesday 22 June 1932 tells of a large rockfall at Crows Rock,

The two levels of Rock Houses at Holy Austin Rock. (Author's collection)

Top level of the now abandoned Rock Houses. (Author's collection)

also known as Vale's Rock, when 5 tons of rock – one piece the size of a car – fell close to sixty-four-year-old Harry Reeves as he was sitting outside his house. Another much smaller rock struck him on the head and a second on the back of the neck. The two levels of houses here were inhabited until the 1950s when they were fenced off as dangerous. A further 85 acres were gained by the Trust between 1964 and 1980 and in 1967, when the last two families were forced into moving to better accommodation by legislative order, the Holy Austin Rock tourist café opened in 1951, now finally closed. The site was abandoned and subject to vandalism, the National Trust having already demolished two of the houses in 1964.

In 1989 their importance was recognised and a £750,000 plan was launched to preserve the unique Rock Houses. While the two upper levels remain unrestored, the first house was reconstructed in 1992. Today visitors can see how the Victorians would have lived in the Holy Austin Rock cave and in the Martindale Caves, another is set to show life in the 1930s.

The Rock Houses in this remnant of the Mercian forest were possibly the inspiration for the hobbit holes in J. R. R. Tolkien's book *The Hobbit*.

The top of Kinver Edge and site of the Iron Age fort. (Author's collection)

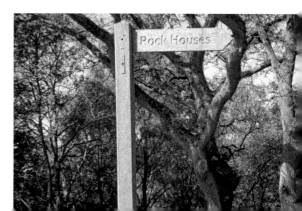

Signpost on Kinver Edge pointing to the Rock Houses. (Author's collection)

The Bower, Lichfield

There is some suggestion that the Lichfield Bower was first instituted by King Oswiu of Northumberland, later Bretwalda or Overlord of Mercia, in AD 657. It's generally accepted though that its foundation lay with King Henry II's Statutes of Arraye in 1176, later confirmed by King Edward I's Statute of Winchester on 8 October 1285.

As there was no standing army to defend the country, King Henry I set up a Commission of Arraye, to set in military order that throughout the Kingdom all men between the ages of fifteen and sixty who were capable of bearing arms should be inspected by the magistrates and be counted on one day in the year, and the numbers submitted to the Commission.

In Lichfield the Courts of Arraye were traditionally held on Whit Monday, where after inspection the men would march through the streets to the 'Bower House', a structure built of wood and boughs, decorated with laurel and lilac – hence the name – at Greenhill. There, a feast of roast beef and spirits was offered, which ensured a good turnout.

The band leading the Lichfield Bower procession. (Photo Averil Shepherd, Calendar Customs)

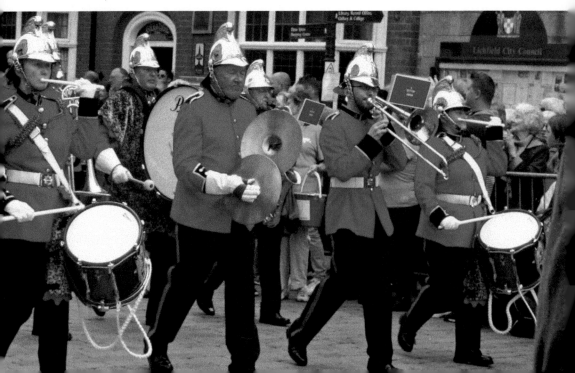

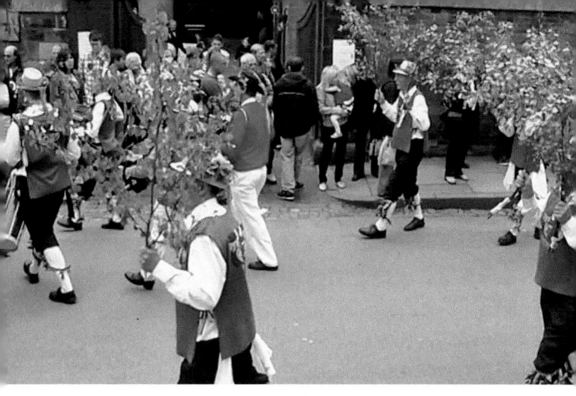

Carrying the green bowers in the procession. (Photo Averil Shepherd, Calendar Customs)

Every Freeman was obliged by law to defend his city and to serve in the country's defence with his own equipment subject to the annual value of his land or goods. These could be a hauberk (coat of mail), an iron breastplate, a sword and a knife, a horse – if the size of his landholding demanded it – or simply a sword, bow and arrows, a gisarme (bill or battle-axe) and simpler weapons. Each had to appear with 'Masses of yron and gaddes of stele, And gisarme for to smyten wele'.

No man, unless it was considered urgent, could be compelled to leave the country and sometimes even their own county. For centuries, each man had to keep his weapons at home ready to be inspected twice yearly by two parish constables, though later armoury was held more securely in local church towers.

Prior to the Reformation the men-at-arms were accompanied by Morris dancers with tabor and drum and as a celebration of Whitsun, parishioners from local churches carried statues of the saints garlanded with flowers known as 'posies'. Post-Reformation the saints were replaced with tableaux representing the city's different trades, but the term 'Posie' continued to be used.

The introduction of muskets and musketeers in the sixteenth century led to them being included in the procession, which would stop at regular intervals outside the houses of noble citizens. Here the musketeers would fire a volley of shots over the house, and the householder would then be expected to provide cakes and ale to all those in the procession. If he failed to answer when called by the Burgess, the householder was fined one penny. This continued until late

evening when the participants, who by now would had drunk a fair amount of ale, staggered back to the market place where the Town Clerk dismissed them.

A report in 1604 declared 'Leichfield Town, able men 285, armed men 150, pioneers 50, high horse 50'.

By the reign of William and Mary, 1689–1702, the country had a standing army, so the Courtes of Arraye were abolished in 1690 except for Lichfield where the locals continued to enjoy the festivities for some time. However, at some point, it must have been discontinued as the Bower was revived again on Whit Monday 3 June 1816.

Today, most of the traditions survive – apart from firing muskets over houses. On spring bank holiday Monday, the Court of Arraye is held in the Guildhall where the mayor inspects the 'men-at-arms' before the Bower Queen is crowned outside at 12 noon. The procession, which includes military bands, Morris dancers and lorries and trailers carrying the 'posies' or tableaux, then journeys to Beacon Park where there is entertainment, food and various stalls.

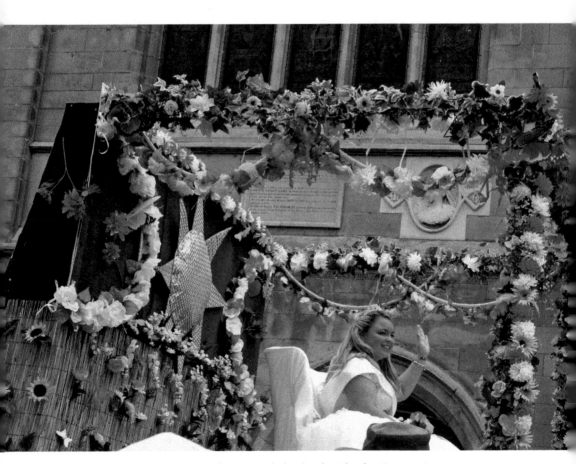

The Lichfield Bower Queen. (Photo Averil Shepherd, Calendar Customs)

William Billinge, Longnor

William Billinge was born in 1679 and is probably Staffordshire's most famous soldier, whose bravery changed history. Yet he was a poor boy born literally in a cornfield at Fawfieldhead near Longnor.

Aged twenty-three he enlisted in the military during the reign of King William III and served under Sir George Rooke, Admiral of the Fleet at the capture of Gibraltar, 1–4 August 1704. He later went on to serve for ten years under John Churchill, the 1st Duke of Marlborough, the son of a Dorset Cavalier squire called Winston Churchill.

The Duke was famously unbeaten in battle and similarly always captured any place to which he had laid siege. Perhaps unusually for the time, he cared for the safety and welfare of all his troops. It was in the War of the Spanish Succession that William found himself at the sieges of Osten, Lisle, Mons and Bethune.

It was during the Battle of Ramillies in Belgium on 23 May 1706 that William, one of a 62,000-strong army, found himself fighting immediately alongside the Duke, who subsequently fell from his horse, becoming trapped underneath its body. The French dragoons were quick to take advantage and despatched a raiding party to capture their prize, but William Billinge was too fast for them. Seeing his commanding officer in trouble he gathered a small force of foot soldiers to surround the Duke and protect him. A fierce hand-to-hand fight ensured during which William was shot in the spine with a musket ball, but he managed to hold on until Marlborough was rescued by aide-de-camp Captain Molesworth, and the French party fled. As Colonel Brinfield, the Duke's secretary, was helping Marlborough to re-mount his horse, the former was struck and killed by cannon shot. As for William Billinge, the musket shot was considered too dangerous to remove and remained there for thirty years before gradually migrating to a position where it was able to be safely taken out. William was then presented with it as a memento of the day he saved the Duke of Marlborough's life. If it wasn't for him England's greatest soldier would have been slain at Ramillies Bay.

In 1712 Billinge's military adventure abroad ended and he returned home to civilian life, though not for long as in 1715 he was back in uniform helping to put down the Stuart rebellion. Then at the age of sixty-six, he donned the colours once again for the second Stuart rebellion of 1745. Possibly William was one of the 13,000-strong army camped at Stone under the command of the Duke of Cumberland waiting for Bonnie Prince Charlie and his 7,000 followers. The rebels, however, bypassed Stone and any conflict on their march to Derby.

William Billinge died in a cottage bordering the same cornfield in which he had been born 112 years earlier, and he was buried close to the door of the parish church. He was the last surviving soldier to have fought with the Duke of Marlborough and had he been born to a later generation would surely have received the Victoria Cross for his bravery. The inscription on his headstone reads as follows:

In memory of William Billinge who was born in a cornfield at Fawfieldhead in this parish in the year 1679. At the age of 23 years, he enlisted into His Majesty's Service under Sir George Rooke and was at the island fortress of Gibraltar in 1704. He afterwards served under the Duke of Marlborough in the ever-memorable battle of Ramillies fought on 23 May, 1706 where he was wounded by a musket shot in the thigh. He afterwards returned to his native country and with manly courage defended his Sovereign's rights at the rebellions of 1715 and 1745. He died within the space of 150 yards of where he was born and was interred here, the 30 January, 1791, aged 112 years.

On the back of the stone:

This stone was placed here by public subscription in 1903 and is a facsimile of the original stone which was removed at the same time being in process of decay. Rev. A. E. Brown, Vicar.

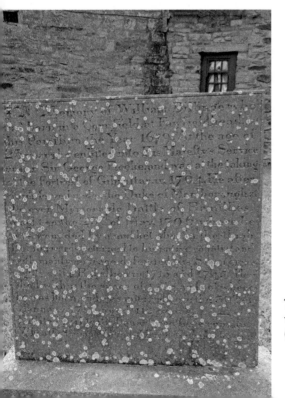

The grave of William Billinge inscribed with his remarkable life story. (Author's collection)

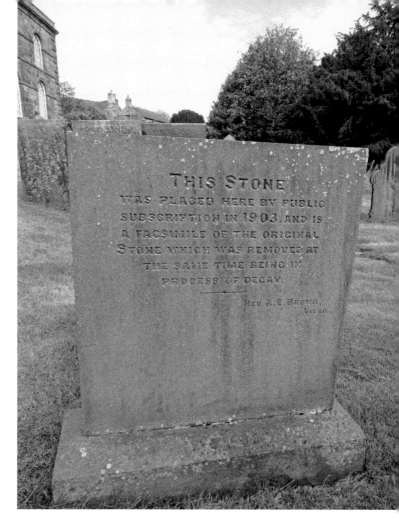

THIS STONE WAS PLACED HERE BY PUBLIC SUBSCRIPTION IN 1903, AND IS A FACSIMILE OF THE ORIGINAL STONE WHICH WAS REMOVED AT THE SAME TIME BEING IN PROCESS OF DECAY.

REV. A.E. BROWN, VICAR.

The inscription on the rear of William Billinge's gravestone. (Author's collection)

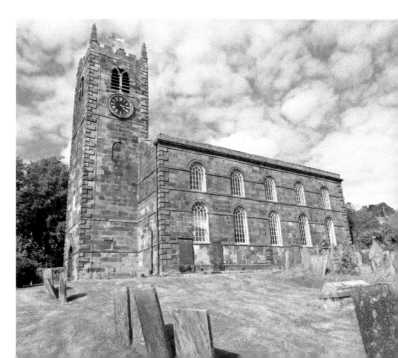

St Bartholomew's Church, Longnor. Nearby is the grave of William Billinge. (Author's collection)

Lud's Church

The Back Forest in the Staffordshire Moorlands hides a secret. Lud's Church, or Ludchurch, is a natural 'cathedral' around some 200 yards long with walls of rock 60 feet high and with a width of only 8 feet. It is claimed that a squire of Swythamley once leapt over the chasm while hunting, giving it the nickname 'Trafford's Leap' after his family name. Even on the hottest summer's day, it is damp and cool, overgrown with ferns, moss and other vegetation covering the walls. Not surprisingly, in ancient times, it was thought to be the home of the devil and according to legend was created by him when he scraped back the earth with his fingernail.

The chasm's formation within a thick bed of coarse carboniferous sandstone or Roaches grit was likely to be post-glacial when a great section of rock to the north-east side moved slightly downhill towards the Dane Valley causing an open rift.

Legend has it that Robin Hood and Friar Tuck stayed there, as did Bonnie Prince Charlie who supposedly used the chasm as a hideout on his way to Leek at the 1745 uprising.

While some think the name may be a link to the Celtic god Llud, it is often assumed to be derived from Walter de Ludank or Walter de Lud-Auk, a follower of John Wycliffe, the thirteenth-century church reformer.

Wycliffe died in Lutterworth, Leicestershire, in December 1384 before a statute of 1401 declared that his followers, known as Luddites, be persecuted, so leading them to worship in secret places. Wycliffe was later declared a heretic at the Council of Constance on 4 May 1415.

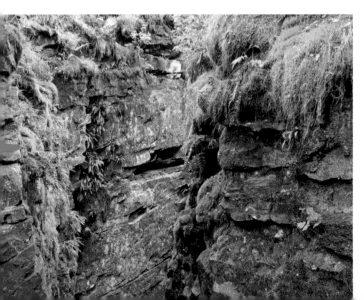

Close-up of the damp, overgrown walls at Lud's Church. (Author's collection)

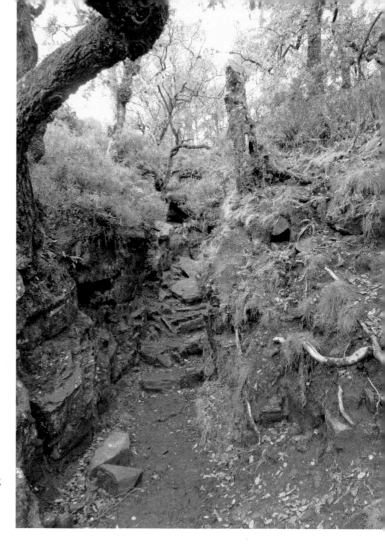

The small entrance to Lud's Church disguising the hidden cavern beyond. (Author's collection)

It was while the Luddites were meeting at Lud's Church in the early fifteenth century that a group of soldiers attacked them, capturing Walter de Lud-Auk. In the mayhem, Walter's eighteen-year-old daughter – some say granddaughter – Alice was killed. She is said to be buried under an oak tree close to the chasm entrance. Later, *c.* 1862 the then landowner Philip Brocklehurst placed a wooden figurehead from the ship *Swythamley* on a high rock edge in the chasm. Known as 'Lady Lud', it was said to commemorate Alice's death.

There is some suggestion too that the medieval poem 'Sir Gawain and the Green Knight' was written in a dialect of the Staffordshire/Cheshire border and that Lud's Church was 'The Green Chapel' setting in the climax of the poem. Furthermore, the chasm is rumoured to be haunted by the ghosts of Alice and a headless figure, reflecting the beheading ritual of Gawain and the Green Knight.

Some 350 years ago on a particular 7 July a man stood in Leek Market Square bearing a sack out of which he emptied a large quantity of snow that he had bought from Lud's Church. That year it was Staffordshire's all-year-round snowfield.

Poison Grave, Wolstanton

In the churchyard of St Margaret's, Wolstanton, close to the east side of the church lies an unusual, if not unique grave. The inscription reads as follows:

Here lieth the body of Sarah Smith daughter
Of Samuel and Martha Smith of Bradwell Park
Who departed this life Nov. 29, 1763,
In the 21st year of her age-
It was C----SB----W,
That bought me to my end
Dear parents mourn not for me,
For God will stand my friend.
With half a pint of poyson
He came to visit me.
Write this on my grave
That all that read it may see.

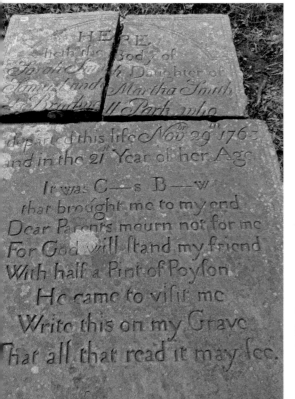

The grave of Sarah Smith, who it's claimed died by poisoning. (Author's collection)

The grave of Henry Fauld, fingerprint pioneer. (Author's collection)

According to local historian Jeremy Crick, C-----SB----W, the man Sarah Smith accused of her murder, was Charles Barlow, a wealthy farmer from Red Street who lived in the parish – indeed he was baptised at St Margaret's on 12 September 1736. However, Sarah was not the average victim of an older man – Barlow was twenty-seven when she died. She was the daughter of Samuel Smith, who had been appointed as the Chief Constable of Tunstall Manor Court in 1759, an important civil office. The constable was responsible for keeping order during court sessions.

Beginning in medieval times and known as the Courts Leet, they were set up to serve and record manorial business and to ensure that correct standards in agriculture and food sales were adhered to. The court jury did not try offenders as in a modern court but indicated or formally accused suspected wrongdoers and helped to decide their punishment. They were later superseded by the Magistrates' Court.

According to the church records Sarah was buried on 4 December 1763, only five days after her death, which was probably not unusual at the time. However, given her father's position and the seriousness of the crime (being murder), it does appear there was little time to investigate the case and her burial was surprisingly hasty.

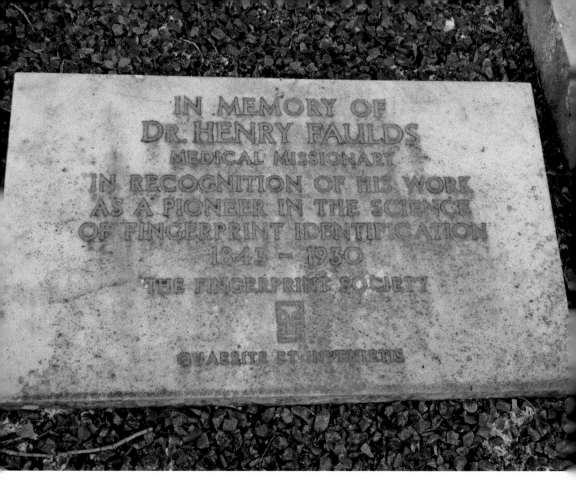

Close-up of the plaque on Henry Fauld's grave. (Author's collection)

Another interesting entry in the Wolstanton parish records which may or may not be connected is the baptism of a baby named Sarah on 4 December 1763, the daughter of Sarah Smith with the absence of a father's name. Could she have been the same Sarah and the child's father Charles Barlow? Perhaps he murdered Sarah to prevent her speaking out. Or maybe her father Samuel had pressured him into marrying his daughter and the reluctant groom turned to poisoning as a means of escape.

At the time Charles Barlow was a single man and he later went on to marry Mary Nixon on 9 April 1765 at St Giles' Church, Newcastle. No one was ever charged with Sarah Smith's murder and the circumstances remain a mystery. If it was Barlow, he escaped justice and at that time the hangman.

A second interesting grave lies in St Margaret's churchyard, that of Henry Faulds (1843–1930). He was the pioneer of fingerprint science whose work would lead to the conviction of multitudes of criminals. At a different time, Faulds' work may have led to the discovery of Sarah Smith's murderer. Incidentally, as a young girl my grandmother often ran errands for his sisters.

THE REMAINS OF TUNSTALL MANOR COURT LEET.

Tunstall Manor Court Leet, where Sarah Smith's father Samuel served as Constable.

St Margaret's Church, Wolstanton, where the notorious 'poison grave' can be found in the churchyard. (Author's collection)

Part Two: More Unusual Stories

Beating the Boundary

One ancient summertime custom involved the circumnavigating of the fields and orchards to bless the growing crops. This took place on the three days prior to Ascension Day (Holy Thursday, the fortieth day of Easter) known as Rogation Monday, Tuesday and Wednesday from the Latin *Rogatio* – an asking. Until the Reformation it was performed with great ceremony. The Lord of the Manor together with robed priests and other clergy carrying the processional cross would be followed by parishioners with banners, hand bells and staves as they walked around the parish boundary, pausing at wayside crosses and landmarks to pray for mercy and to bless the crops. Also, young boys armed themselves with long willow or birch twigs with which to beat the landmarks and sometimes they too were bumped against the marker or even beaten so they would remember the information being passed on to them. Meanwhile the women and girls wore and carried garlands of flowers while the Litany of the Saints was read. At other places they were permitted 'the drinking of good cheer', which is perhaps strange as in the Church calendar Rogation Days were appointed fast days.

This tradition lies behind the place names 'Gospel Oak' and 'Gospel End', indicating stopping places where the Gospel was read, and are always to be found on or close to a parish boundary.

Following the Reformation, the religious element was discouraged. 'Beating the bounds' became more of a civic custom and the stopping places a great stone, a well or a spring. At a time when literacy was the preserve of the few it became important for older parishioners to point out the boundary markers where their evidence was written down in the presence of witnesses and the records deposited in the parish chest. Following the Dissolution of the Monasteries – where welfare was provided – the poor laws of 1558–1603 were introduced. In some parishes this led to unscrupulous churchwardens and overseers ignoring ancient landmarks so as to purposefully disown poor parts of their parish in order to avoid responsibility for those needing relief and in turn reduce the parish tax levied to pay for them.

Later, a document from Alrewas in 1794 suggests that the custom fell into disuse during the Civil War of 1642–51, though later reports show parishioners to be very precise in their quest, often wading through rivers to follow the exact boundary. One particular record from 1861 in Bilbrook tells of a cottage and outbuildings which straddled the boundary of Brewood and Tettenhall parishes and where the younger members of the procession climbed over the said roofs.

In Penkridge the Rogation continued until 1820, though in the city of Lichfield a different tradition began.

Since at least 1548 when Lichfield was granted a city charter by King Edward VI, a perambulation of the boundaries was held in view of the Sheriff of Staffordshire. Before then, although there is no record, it probably took place at Rogation time accompanied by the clergy. In 1553 Queen Mary I made Lichfield a 'city and county' separate from Staffordshire and with the right to appoint its own Sheriff in thanks for their support during the Duke of Northumberland's rebellion. The charter required that the Sheriff should 'perambulate the new county and city annually on the Feast of The Nativity of The Blessed Virgin Mary', 8 September. It was later confirmed by King Charles II 'The Bailiffs and common councilmen shall annually on the Nativity of The Blessed Virgin perambulate the boundaries of the city and county of Lichfield and the precincts thereof.' At the time, it was the Burgesses who appointed the Sheriff and he in turn had responsibility for the prison, gallows and keeping the neck collars and shackles. Lichfield returned to Staffordshire in 1888 and the Sheriff's duties became largely ceremonial as an appointee of the City Council.

The Sheriff's ride is a unique tradition and there is a reference in the register of St Michaels' Church which states 'Paid for an (sic) horse for Mr Hobbocke the Curate at ye perambulation Xiid (5p)' and a later ruling was passed in the

The Lichfield Sheriff's ride processing through the city. (Photo Ross Parish, Pixyled Publication)

Lichfield court of 1645 which ordered that at least one member of each household should accompany the Sheriff or pay a fine.

Today, on the Saturday closest to 8 September, the riders gather outside the Guildhall around 10.30 a.m. The Sheriff and other civic dignitaries then lead the procession of horses out of the city on a marked route that appears to have lengthened over the years from 16 miles to approximately 22 miles, taking in bridleways, private land, with cross-country cantors and gallops, and some roads before returning to the city and the cathedral to be greeted by the Dean. Sword and mace bearers then escort the riders back to the Guildhall in the early evening.

Jack of Hilton

The strange custom involving Jack of Hilton is unique in this country and relates to the Manor of Essington which in Norman times belonged to the Barony of Dudley, but was later held by the neighbouring Lord of Hilton – the Swynnerton family – under a peculiar feudal service known as 'jocular tenures'.

Jack, a hollow brass image of an indecorous man kneeling on one knee, originally belonged to the Manor of Essington. At around a foot high, he has two apertures, one at the back some two-thirds of an inch in diameter and the second at the mouth, the size of a pin head. Known as an aeolipile after Aeolus, the Greek god of air and wind, the figure is ancient, possibly Saxon, though some experts date it to circa 1300; others claim it to be Etruscan in origin and brought to England by the Romans. Anthropomorphic aeolipiles, or hearth blowers – the steam blew the fire – are generally medieval with influences from the late classical period (Greek 400–300 BC). In continental Europe, they were not uncommon and similar ones have been found as far away as the Himalayas.

Under the feudal charter the tenants of Essington Manor were obliged to bring a live goose to Hilton each New Year's Day and drive it three times around the central fire in the main hall. Meanwhile 4 pints of water were poured into the hole on the aeolipile's back which was stopped up before Jack was placed on the fire, causing the resulting steam to blow and wheeze from his mouth. When hot enough the image would spin due to the pressure created – a precursor of the steam engine, which would later fuel the Industrial Revolution. The perambulation with the goose had to be completed before Jack ran out of steam. The poor goose was then despatched to the kitchen and delivered to the cook. When the bird was ready the Lord of Essington – or more likely his bailiff –carried it on a dish to the table where he received a platter of meat in return. The tenant received his title deeds for another year from the Lord of the Manor.

No records survive as to when this custom began but it is said to have been performed without interruption for over a 140 years before becoming obsolete when the Swynnerton heiress married a Vernon in 1562 and both manors became owned by the same family. How such a figure came to be used in such an unusual Staffordshire custom remains a mystery.

Today Jack of Hilton resides in the Ashmolean Museum in Oxford where the label reads, 'For many years he performed an important function in an annual ritual (involving a goose) attending the granting of tenancies within the manor estates.'

Jack of Hilton, the aeolipile effigy. (Photo Ross Parish, Pixyled Publications)

The Minstrel's Court and Tutbury Bull Running

Tutbury Castle was rebuilt by John of Gaunt, Duke of Lancaster, following damage sustained in the civil war between King Stephen and the Empress Matilda 1139–54. In 1371 he married the Spanish Princess Constance, daughter of Pedro the cruel of Castile, through which he claimed the title King of Castile. The Duke's court at Tutbury had a reputation for merriment and festivities which attracted minstrels from all parts of the realm, and some were even brought from Spain. With so many artisans, disputes would often break out and it became necessary to keep order amongst them. So, the Court of Minstrels was instituted, to be held following the Feast of the Assumption, 15 August, headed by a king and granted legal status with a charter by John of Gaunt. A second charter was granted by King Richard II and confirmed by King Henry IV in 1381 'In the 21st year of his reign to licence trumpeters and other minstrels. Granted under our privy seal at our Castle of Tutbury', which was the court of the Royal Duchy of Lancaster.

The Court of Minstrels had a similar function to the tradesmen's guilds at the time as musicians had a professional status as entertainers; indeed, no one could claim to be a minstrel without undertaking seven years of training. Therefore, governed by a King, the court better regulated and encouraged their art, and juries of minstrels would adjuvate in complaints and disputes. There was concern

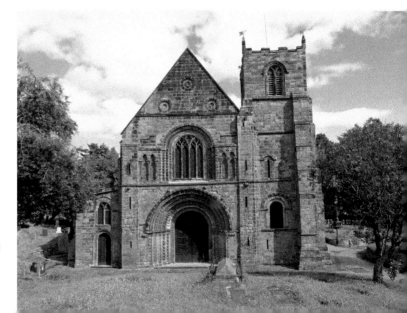

St Mary the Virgin Church, once part of Tutbury Priory. (Author's collection)

amongst the minstrels that fines and punishments levied by the King were too severe and the foundation of the court enabled it to issue fines within the trade. Initially the court presided over Staffordshire, Derbyshire, Nottinghamshire, Leicestershire and Warwickshire, but by *c.* 1630 Charles I limited the jurisdiction to Staffordshire and Derbyshire. All the minstrels were compelled to attend the court or pay a fine, which by 1630 was 4/6d (22.5p) – a considerable amount.

On 16 August, the minstrels would assemble at the Bailiff's Mansion House before departing for a service in the priory church of St Mary and afterwards form a procession to the castle hall, where the King of the Minstrels was seated between the Steward and Bailiff. Proceedings began with the calling of the names of the minstrels from which two juries were selected – twelve men from Staffordshire and twelve from all the other counties combined. In turn elections for four new stewards – two from Staffordshire and two from other counties – were held, with the King selected from amongst the four stewards voted into office the previous year. As a token of his sovereignty the King of the Minstrels was presented with a white staff or wand – album baculum – when he presided over the court.

A far more gruesome tradition was introduced by John of Gaunt in 1377 to honour his wife's Spanish heritage. Some claim it had pagan roots, but bull baiting became a popular sport in the late medieval period.

An ancient privilege within the Honour of Tutbury – Honour being a group of Manors with peculiar rights and privileges – was that all minstrels who attended Matins on the Feast of the Assumption of the Blessed Virgin Mary were given a bull by the Benedictine Prior of Tutbury.

Outside of the Priory gates between 4–5 p.m. the minstrels waited for the poor bull to be let loose minus his horns, ears and tail, his nose filled with pepper and covered in grease. If a minstrel was quick enough to catch the creature and remove only the tiniest tuft of hair then the bull was theirs provided he was caught

The main street in Tutbury where the medieval bull running took place. (Author's collection)

in Staffordshire – the River Dove is the boundary with Derbyshire – and before sunset. The bull was then roped and taken to the Market Cross where it was baited and killed by dogs. The minstrels were served it roasted later at their feast.

According to the charter anyone other than a minstrel who encroached within 40 yards of the bull would receive a penalty, though in time the general crowd began to join in the chase and this, understandably, led to rivalry between Staffordshire and Derbyshire, resulting in the inevitable fight.

Tradition says that Robin Hood visited the Court of Minstrels and a fourteenth-century ballad suggests that he married at Tutbury 'on the day of the bull-running'.

Following the dissolution of the Priory in 1538, the estate passed to the Duke of Devonshire who took over responsibility for presenting the bull, which by now was loosed from a barn belonging to the town Bailiff.

Later, in the eighteenth century Vicar of Tutbury Joseph Dixon appealed to the 5th Duke of Devonshire, William Cavendish, to discontinue the bull run. It was eventually abolished together with the Court of Minstrels in 1778 after a man died in the subsequent mass brawl. The court however, continued to be held unofficially at the Steward's House on the castle site into the nineteenth century, eventually falling into disuse sometime between 1817 to 1832.

Furthermore, not far from Tutbury was Needwood Forest where a modest cottage occupied a site close to where Barton-under-Needwood church now stands and where the future King Henry VII passed by while out hunting circa 1480. It was the home of a couple named Taylor who had been blessed with triplets – three surviving boys – a rarity in the fifteenth century, and so they were shown to the Earl of Richmond. Henry commanded they be taken care of and all three went on to become successful doctors.

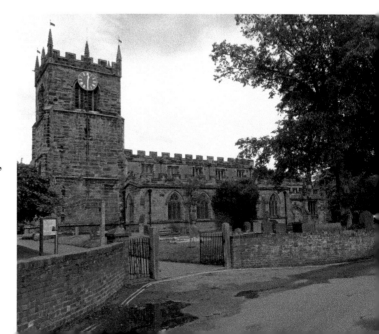

St James' Church, Barton-under-Needwood, financed by John Taylor, who became 1st Master of the Rolls and ambassador to France during the reign of King Henry VIII. (Author's collection)

John Taylor was appointed 1st Master of the Rolls and Ambassador to France by King Henry VIII and accompanied him to the Field of the Cloth of Gold in Pale of Calais in 1520. His coat of arms bore 'three violets slipped between three children's heads couped at the shoulder'. Even so, John never forgot his childhood home and built the church of St James, between 1517 and 1533, near to his family's cottage.

The tower at Tutbury Castle, seat of the Duke of Lancaster. (Author's collection)

Mock Mayor

Newcastle's Mock Mayor ceremony took place at the Market Cross and is a rare civic tradition. Market crosses were generally erected to remind the nearby stallholders to deal honestly and fairly and not to cheat with weights and measures or to overcharge customers. They were also the site for general gatherings, manorial Leet Courts and even public whippings.

In 1235 King Henry II granted a Free Borough charter to Newcastle-under-Lyme with a formal system of Mayor, Bailiffs and Burgesses the latter of whom would elect the Mayor. This system continued until a further charter by Queen Elizabeth I on 18 May 1590 when the Borough Corporation succeeded in getting the power and privilege to elect the Mayor restricted to its own members, known as Capital Burgesses. Understandably, the Burgesses who lost their rights of election were not pleased and as a way of protest, elected their own Mayor immediately after the official ceremony. For the next 245 years, the election of the Mock Mayor – a parody of the official Mayor, was held by a popular informal assembly of townspeople in opposition to the Burgess's chartered rights, which annoyed the local dignitaries and often the Mock Mayor found himself put in the stocks. It began at the Market Cross where the freemen elected a candidate

Below left: Newcastle Guild Hall, next to which the Mock Mayor ceremony was held. (Author's collection)

Below right: A set of stocks similar to those which would have been used to punish the Mock Mayor. (Author's collection)

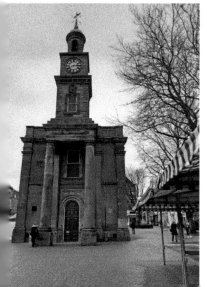

Mock Mayor by Robert William Buss.

during a ceremony which ridiculed and poked fun at the solemn formality of the official event. Firstly, the nominee was summoned to appear by the blast of a nanny-goat horn to answer before the crowd if he had any objection to filling the office and 'the customary privileges of getting drunk and finning himself publicly as an example'. After accepting the terms, he was then led by a group of townsmen to the top step of the Market Cross where he was invested with a robe of state and a wand of office before bringing forth his wife, who was introduced as the Mistress Mayoress. Later, with the Mayoress seated on a donkey and the Mock Mayor accompanied by his companions they led a procession through the streets collecting money to pay for the evening's celebration. It was not until the Municipal Reform Act of 1835 that the town Burgesses recovered their chartered rights to elect the Mayor.

The Mock Mayor ceremony continued as a festival. A report of 1842 records that Wednesday 9 November was the Day of Mayor Choosing and was considered to be a general holiday with the ritual performed by employees of Mr Mason's hat manufacturers. A band of musicians led the procession with the Mock Mayor and Lady and civil dignitaries all played by hatters mounted on horses. Many other workers from the factory walked behind – two abreast and wearing rosettes – on their way to the Market Cross. There, his Worship was proclaimed

Mayor. Afterwards everyone was treated to a supper of roast beef and ale paid for by Mr Mason and by a local collection. Meanwhile, the spectators celebrated too, no doubt in the local pubs.

In the eighteenth century, Hanley and Shelton were not to be outdone by their neighbours and devised a Mock Mayor feast of their own. This was sometimes called the Venison Feast on account of the Marquis of Stafford supplying a deer for the annual festivities.

Mr Stephen Chatterley became the first person to be 'appointed to the honour of being Mayor of Hanley and Shelton' on 18 September 1783 followed by Mr Ralph Badderley on 30 September the following year when the ceremony and subsequent feast was attended by seventy gentlemen, some of whom were visitors from Newcastle. To add some formality to the occasion, the names of all those present were recorded in the so-called Corporation Book and anyone wishing admittance to the freedom of this supposed Corporation had to successfully drink a yard of ale in one draught.

The custom continued until at least 1843 when it was included in John Ward's *The Borough of Stoke-upon-Trent.*

The Market Cross, Newcastle, from where the Mock Mayor was proclaimed. (Author's collection)

Moorland Wallabies

For many years, unsuspecting late-night motorists had been convinced that they'd seen a kangaroo in their car headlights when traveling the moorland roads, only to be asked if they'd exceeded the drink/drive limit! However, they had not imagined it. What they had seen was one of the local wallabies.

Lieutenant Henry Courtney Brocklehurst, born 27 May 1888, of Swythamley Hall, served as a Royal Flying Corps pilot in the First World War, later becoming a colonial adventurer and game warden in Sudan. Returning home, he purchased two Tasmanian Bennett's wallabies in 1936 from Whipsnade Zoo, additions to his collection of yaks, llamas and apes housed on the estate.

His menagerie though, was short-lived as at the beginning of the Second World War regulations were introduced prohibiting the keeping of private zoos, so in around 1939/40 five wallabies and three yaks were released into the wild to save them from euthanasia. Sadly, Henry Courtney died fighting the Japanese in Burma aged fifty-four in June 1942.

While the yaks died out in the 1950s, the wallabies thrived in number to a colony of over fifty living around the Roaches – from French *les roches* or rocks,

A Bennett wallaby similar to those released onto the Staffordshire moors.

so named by French prisoners captured in the Napoleonic Wars. That is until the harsh winter of 1963 when the peaks and moorlands lay under a blanket of deep snow for over two months and around half of them were thought to have perished.

The remaining wallabies continued to be spotted and despite stories of hunters shooting them, by the 1970s there were some sixty living on the moors. Standing around 1 metre tall, they had to compete with the sheep for food – mainly heather – and the increase in human visitors saw their numbers drop. The last official sighting was in February 2009.

The Peak District covers 555 square miles and sightings continue to be reported. Because wallabies are known to prefer places with wild water, there is some suggestion that they may have moved to Hamps Valley and the River Dove. Many people insist they are still around and visitors to the area always scan the moors hoping to see one.

The Roaches, home to the wild wallabies released by Henry Brocklehurst in 1940. (Author's collection)

Norton-in-the-Moors and Marriage

Many old customs surrounding marriage have prevailed across the county; for example, if a courting couple exchanged locks of their own hair, it was considered to be a formal engagement, and it was thought unlucky for an engaged couple to be godparents or photographed together. Meanwhile, in South Staffordshire, it was a tradition to invite all the neighbours to play sports, usually football, as part of the celebration with one parish competing against another. The ball was provided by the bridegroom and called the 'bride ball'. Another tradition was the practice amongst poorer families of the bride and groom going to church without their parents or families and with just the best man and bridesmaid in attendance.

In 1653 Oliver Cromwell's Little or Barebones Parliament legislated that marriage was to be only a civil contract and the names of couples intending to marry should be read out in church or at the market place on three successive occasions. Usually, it was the town crier who called out the proclamations at the Market Cross. This Puritan law also meant that marriages had to be undertaken before a Justice of the Peace, so dividing the religious sacrament from the legal contract, which unsurprisingly, caused resentment amongst the clergy. Examples of this was the marriage between Mr John Milward and Miss Jane Sneyd on 27 January 1656 at St Margaret's Church, Wolstanton, by Edward Brett, esquire Justice of the Peace for the county of Staffordshire and also at Wolstanton, the marriage of Richard Marsh and Ann Rowley on 23 December 1656 by Edward Eardley JP, whose intentions to marry were announced at the Market Cross, Newcastle-Under-Lyme. Though perhaps even more odd was a marriage registered in 1654 at Stafford when the town's rector, Revd Robert Palmer, was married by the Borough Mayor, Thomas Backhouse, following proclamations on three successive Saturdays at the market.

The Commonwealth apart, marriages had to be conducted by members of the Anglican clergy. However, there were a number of so called 'lawless churches' which managed to claim exemption from ecclesiastical jurisdiction, and here vicars carried out irregular marriages which were legal. These were usually where the clergyman had the 'living' of the parish and so were less likely to risk disproval from the relevant authorities.

One such parish was Norton-in-the-Moors, then a remote moorland landscape where St Bartholomew's Church sits on the summit of a hill some 2 miles from Burslem. Dating back to Saxon times, it was rebuilt in 1737–8 and had

a reputation as being Staffordshire's Gretna Green. Perhaps due to its location the parish claimed exemption from the formality of banns or the requirement to produce a licence and became the destination for many an anxious couple, confirmed by the unusually high number of marriages recorded there.

Irregular marriages though, were finally outlawed in England by Hardwick's Marriage Act of Lady Day 25 March 1754, which required the bride and groom to undertake a formal marriage ceremony.

A signpost showing the route taken by King Charles II from Boscobel House to Mosley Old Hall. (Author's collection)

The Church of St Bartholomew, Norton-in-the-Moors, which was once the Gretna Green of Staffordshire. (Author's collection)

Oak Apple Day

Oak Apple Day, also known as Restoration Day, Royal Oak Day, Oak and Nettle Day or Shick-Shack Day, was a public holiday held annually on 29 May to celebrate the restoration of the monarchy on the thirtieth birthday of King Charles II in May 1660.

In that year a law was passed by parliament, an 'Act of a perpetual Anniversary Thanksgiving on the Ninth and Twentieth Day of May for keeping of a perpetual Anniversary For A Day of Thanksgiving to God for the great Blessing and mercy He hath been graciously pleased to vouchsafe to the people of these kingdoms, after their manifold and previous sufferings, in the Restoration of his Majesty with safety, to his people and Kingdoms; And that the nine and twentieth Day of May, in every year being the Birth Day of his sacred Majesty's Return to his Parliament be yearly set apart for that purpose'. The day was for dancing and parties and the wearing of sprigs of oak and/or 'shick-shacks' – oak apples – the symbol of Royalist supporters. Anyone caught not wearing one was accused of being a Roundhead and thrashed with nettles or pelted with birds' eggs.

In South Staffordshire, the holiday held a special significance as following the Battle of Worcester on 3 September 1651 it was the Gifford family of Chillington who arranged for the king's escape, initially from White Ladies Priory in Shropshire to Boscobel and the Royal Oak Tree on the Shropshire-Staffordshire border, then via Blackladies Benedictine Priory and onto Moseley Hall from where he fled to mainland Europe.

A sprig of oak, one of which would have been worn on Oak Apple Day. (Author's collection)

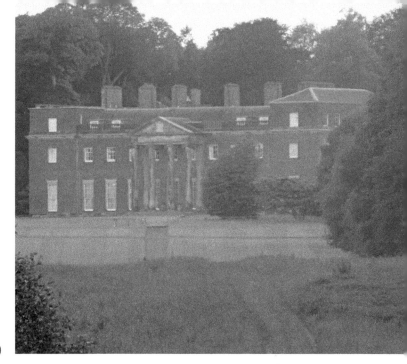

Chillington Hall,
the seat of the
Gifford family.
(Author's collection)

For local people, it became the custom to begin early on Restoration Day with a visit to the houses of Moseley, Chillington and Boscobel before spending the day celebrating and playing sports. One event held close to Chillington involved the schoolboys, half of whom had oak leaves in their caps while the others did not. Watched by the headmaster and parents, the game – or tournament – began with boys sitting on the shoulders of their teammates carrying wooden swords and lances. The objective was for each team to dismount the opposition, although the oak leave contestants always seemed to win. Their captain was then crowned with a garland and for the rest of the day became known as 'King Charlie'.

The holiday was abolished in 1859 under the Anniversary Days Observance Act of 25 March as it was considered too political for a national church. However, in the 1890s many railway engines continued to be decorated with oak bough and the 'Royal Oak' remains the third most popular pub name.

Today Oak Apple Day is still celebrated at Moseley Old Hall and at schools in the area.

Furthermore, the Gifford family appear to have made a habit of confronting the law and rescuing people. In the thirteenth century, the area surrounding Brewood was thick forest subject to forest law, and it is recorded that in 1276 a stag, shot by John Gifford, drowned in White Ladies Priory – properly known as the Priory of St Leonard's – fish pond. Instead of handing it over to the authorities the nuns decided to try some venison and shared the carcass with John Gifford. Both parties were convicted before the forest court but Gifford successfully pleaded that the area had been dissafforested by King John and so escaped with a fine. The nuns were granted a royal pardon 'on account of their poverty and for the good of the King's soul'.

Later, in 1513 Sir John Gifford carried out a remarkable act of bowmanship. Like a lot of established families at the time the Giffords kept a private zoo from which one morning a panther – or in some versions of the story, a leopard – escaped. Together with his son Thomas and armed with a crossbow Sir John set out to search the area. Soon he saw the distant animal about to pounce on a woman and baby. 'Prenez haleine, tirez fort' advised the son as Sir John took aim and killed the beast. Translated as 'Take breath, pull strongly', it has become the Gifford family motto and the panther's head and archer appear on their crest. A replica stone cross – the original is under the courtyard archway – stands in the garden of Chillington Hall's gate lodge. Known as 'Gifford's Cross', it marks the spot where the creature fell.

The replica Gifford's Cross standing where the panther or leopard fell after being shot by Sir John Gifford. (Author's collection)

The Thorncliffe Mermaid

Close to Thorncliffe, high up in the Staffordshire Moorlands, sits the Mermaid's Pool or Blakemere Pool. It is said that cattle refuse to drink there and birds don't fly over its dark, bottomless depths. Even in the hottest weather the water level never changes, nor in the coldest winter does the surface freeze.

According to seafaring legends mermaids – from mere, Old English for sea – were malevolent creatures who could be heard singing enchantingly to sailors, thus luring them from their work and causing the ship to run aground. Other stories tell of mermaids inadvertently squeezing to death drowning men while trying to rescue them. Also, forgetting that humans cannot breathe underwater, they delighted in taking sailors to their watery hideaway while some even suggested that mermaids would deliberately drown men. Not surprisingly in British folklore, mermaids were considered unlucky omens of forthcoming disaster – occasionally being the cause of it – and for centuries, there has been a fear of them in Britain.

The legend of Blakemere (Blackmere) Pool dates to circa 1,000 years ago when a beautiful maiden was persecuted and accused of several offences by Joshua Linnet. Possibly she had rejected his advances and he accused her of being a witch. Whatever the reason, he had her tied up and thrown into Blakemere Pool. As she struggled to free herself she screamed vengeance on Linnet, declaring that her spirit would haunt the pool and one day he would be taken down into the depths of the water. Just three days later Joshua Linnet was discovered lying face down in the pool. When the locals dragged him out and turned his body over, they were horrified to discover the skin on his face had been torn to shreds as if by sharp claws or talons.

A Plaque depicting the former Mermaid Inn at Thorncliffe. The building is around a quarter of a mile from Blakemere pool. (Author's collection)

A second version tells of a sailor from nearby Thorncliffe who fell in love with a mermaid and brought her back from the sea. He was a mortal man and she immortal. When he died, she was left alone in the pool where she wept and pined for him. The pool had become a prison and she longed to go back to the sea. Eventually becoming bitter and angry with humans, she haunted the lake. Half woman and half fish, she is said to rise from the water at midnight to lure single men enchanted by her singing to their death. Meanwhile, others think that perhaps the spirit is that of a 'Mere Maid' rather than a mermaid.

Blakemere's reputation for being bottomless is due to some believing that the pool is linked underground to nearby Doxey Pool by a U-shaped tunnel. During one moorland blaze water was pumped continuously by the fire brigade from Blakemere but the level never dropped. However, geologists have disputed this as both pools are on different levels and the local moorland terrain does not advocate the idea of a U-bend tunnel.

In the nineteenth century, there was an attempt to drain Blakemere to discover if it was indeed bottomless, and work began on digging a ditch from the southern edge, the remains of which can still be seen. Work was halted however when it is claimed that a mermaid rose aggressively from the water threatening workmen that she would drown Leekfrith and Leek if they didn't stop. Terrified, the men fled and the pool still retains its secrets.

Blakemere pool, Thorncliffe, considered to be the Mermaid's traditional home. (Author's collection)

William Willett of Endon

William Willett was born in the early eighteenth century and was a well-known character in the village of Endon, often to be found in the local pub where he enjoyed a drink or two and a wager. He probably lost as many bets as he won, but William was brighter and less gullible than most people took him to be.

In September 1752, England changed from the Julian to the Gregorian calendar, introduced by Pope Gregory XIII in February 1582, almost 200 years after Catholic Europe. Many people thought it a 'Popish plot'.

Prior to the change, travelling to Europe would have been problematic as someone born in France on 8 July – Gregorian – would celebrate their birthday in England on 28 or 29 June – Julian calendar. There was even more confusion the previous year, as 1751 had been reduced from 365 days to 282 with New Year's Day moving from 25 March to 1 January. This meant that the USA's president George Washington, born 22 February 1732, was under the Julian calendar actually born on 11 February 1731. Only after the calendar change did he recognise his birthday as 22 February.

The introduction of the Gregorian calendar from January 1752 meant that the country would have to 'lose' twelve days, so the government planned for this to happen between 2–14 September. William Willett spied his opportunity and offered to wager anyone that he could dance around the village for twelve days and nights without a break. Thinking he had finally gone mad the villagers placed a considerable number of bets, agreeing that it was a way to make some easy money.

William began his dance on the evening of 2 September accompanied by his own tuneless singing, guaranteeing all those in the village heard him. The following morning, 14 September, he stopped to claim his bets, declaring that he was rich. While the validity of William's claim is questionable, he pointed out that gambling debts were a matter of honour and at a time when few were literate, it was their own fault for being duped. He is buried in St Luke's churchyard, Endon.

Landlords too took advantage of the shortened month by charging tenants a full month's rent while only paying them for days worked. It was only after the publication of some strongly worded views by King George II that landlords and employers relented. Moreover, it was common practice in the years following 1752 for the words 'New style' to be written after the date and 'Old style' to follow pre-September dates.

Above: St Luke's Church, Endon. William Willet is buried in the churchyard. (Author's collection)

Below: Endon Old Village, where William Willet would have danced in September 1752. (Author's collection)

The Wychnor Flitch

Another unusual tradition involves the Manor of Wychnor and concerns a side of bacon. It was said that as a condition of the small rent payable to the Duke of Lancaster the Lord of the Manor, Sir Philip de Somerville, should keep a bacon flitch ready at all times in the hall at Wychnor with the exception of Lent, to be claimed by anyone who had been married 'For a year and a day without quarrelling or repenting; and that if they were then single and wished to be married again, the demandant would take the same party before any other in the World.' Another version tells that Sir Philip was famous for his hospitality and instigated the custom himself in 1328.

There is evidence, though, that the tradition is much older in mainland Europe, possibly originating in Saxon times. Historian Helene Adeline Guerber relates that it may be linked to the Norse Yule feast when wild boar meat was eaten to honour the god Freya.

However, anyone making a claim for the bacon at Wychnor had in the first instance to approach the bailiff or porter with the words, 'Bailiff or porter I do you to know that I am come for one bacon flitch, hanging in the hall of the Lord of Wychnor, after the forms thereto longing.' The bailiff or porter would then assign a day for the couple to return with two neighbours as witnesses to give evidence for their claim while two freeholders of the manor would accompany the bailiff. On the appointed day a procession of tenants – and a horse and cart to carry away the bacon – went along with the demandants to the manor house, where the flitch was bought down and laid at the hall doorway, one end on half a quarter of wheat and the other on the same of rye. Kneeling over the bacon before the Lord of Wychnor they swore on oath that 'Neither of them in a year and a day, neither sleeping or waking, repented of their marriage'. If they proved successful in claiming the flitch the couple were ceremonially escorted home with 'Trompets, tabourets and other manor of mynstracie'.

Needless to say, many left disappointed as according to the old records only three couples have won the flitch. One couple were said to have quarrelled about how the bacon should be prepared and cooked, so were judged to have forfeited it. Another couple was a seaman and his wife who after marrying had not seen each other until the day they made their claim in the hall and thirdly, there was an even-tempered labourer whose wife was dumb.

The same, though, could not be said for any village clergyman as a flitch or side of bacon was presented to any Wychnor man in Holy Orders, be it archbishop, bishop, prior or parish priest one year and one day following his retirement.

As no one had tried to claim the flitch for many years it was replaced with a figure of bacon carved on wood. By 1535 the medieval house had been demolished as it was said to be in ruins and subject to flooding from the River Trent. The present Grade II listed hall was built in the early eighteenth century and when Horace Walpole visited in 1760, he reported that no one had claimed the flitch for thirty years.

The custom continued until at least the eighteenth century, and the wooden flitch still hangs in the hall.

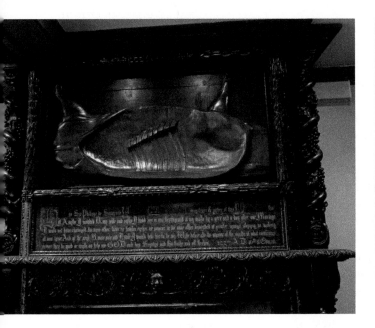

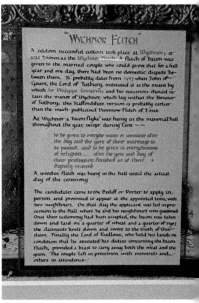

Above left: The wooden Wychnor Flitch effigy. (Courtesy of Wychnor Park Country Club; author's collection)

Above right: Panel describing the story of the Wychnor Flitch. (Courtesy of Wychnor Country Club; author's collection)

Left: The present Wychnor Hall, now a hotel and country club. (Author's collection)

Part Three: Industrial Tales

Coal Miners

As Staffordshire's industry developed in the eighteenth century so too did a number of associated stories and legends in the local communities. Coal miners in particular, given the dangerous nature of their job, were particularly superstitious and a number of omens prevailed; for example, if a miner on his way to work encountered a cross-eyed woman or a one-legged man he wouldn't descend the pit shaft. Similarly, if he spotted a robin perched on a wall, water pump or any other man-made object; however, it was considered ok if the bird sat on something natural such as a tree or bush.

Once underground there were 'Knockers' or friendly goblins. Standing around 18 inches high, they were considered very ugly and dressed in a bizarre imitation of the miners' clothes, even carrying miniature picks and lamps. They were said to give an advanced warning of danger with a distinct knocking sound, though this may have been the cracking of rocks above.

In South Staffordshire it was considered an omen of disaster if the Seven Whistlers were heard at the pithead while in North Staffordshire they were known as the Seven Whisperers. In reality it was probably the cries of wild geese. The same birds were also said to be responsible for the noise heard by South Staffs colliers in the early morning which was described 'as a pack of hounds in the air', often called 'Gabriel's Hounds'.

Above the fireplace in a South Staffs pub was a large board which read (sic):

YE COLLIERS GUIDE OF SIGNES AND WARNINGS.
(1) To dream of a broken shoe, a sure signe of danger.
(2) If you mete a woman at the rising of ye sun, turne again from ye pit, a sure signe of deathe.
(3) To dreame of a fire is a sure signe of danger.
(4) To see a bright light in ye mine is a warning to flee away.
(5) If Gabriel's Hounds ben aboute, do no work that day.
(6) When foule smells be about ye pit, a sure signe that ye imps ben annear.
(7) To charm away ghosts and ye like: Take a Bible AND A Key hold both in ye right hand and say ye Lord's Prayer, and they will right speedily get farre away.

A tradition common to both coalfields is that of a dog howling in the night at the front of a house as it portrayed the death of one of those living there. Though, if the howling was at the back of the house then the family was safe. Moreover, should a collier be unfortunate enough to die in the mine it was the custom in North Staffordshire to lay his clogs upon his grave.

Perhaps the strangest and most gruesome legend surrounds the Harecastle Tunnel.

The Kidsgrove Boggart

The legend of the Kidsgrove or 'Kitcrew' Boggart dates back to as early as circa 1780 in the old hamlet of Ranscliffe where the spirit terrorised the community. It began with the construction of a footrail or tunnel from one of the many coal mines under Ranscliffe Hill to the side of the Trent and Mersey Canal some quarter of a mile from the mouth of James Brindley's Harecastle Tunnel. Here, it is said the boggart made its first appearance, and so frightened were the colliers that they refused to work. Later on, all work would be cancelled for the day or sometimes even longer if there was a reported sighting and the news spread quickly amongst the cottagers.

A Plaque close to the old Harecastle Tunnel entrance. (Author's collection)

The two Harecastle Tunnels. The newer Thomas Telford one in use today alongside the closed James Brindley tunnel. (Author's collection)

The term boggart is Old English for a mischievous or malevolent spirit and in Kidsgrove it appeared in different forms. At night it was seen as a dancing, flickering light in the marshy dales, imitating a nightingale's song and attracting hundreds of miners to listen to the strange bird. At other times a demonic black dog was reportedly seen at the gates of a prominent local family's house prior to a death in their family. The same apparition also foretold of impending disaster in the colliery. Folklore suggested the manifestation of both a white horse and a headless woman. The latter, often accompanied by a blood-curdling scream, was thought to mean doom and disaster. It was claimed to have been seen around the village on the days of several of North Staffordshire's mining disasters.

There are a number of theories surrounding the boggart's origin. One involves a man working on James Brindley's tunnel who was killed in an accident which decapitated him. Another tells of a couple quarrelling as they entered the tunnel, where the man cut off his wife's head in anger before dragging her body into the mine workings and hiding her in a culvert known as 'Gilbert's Hole', once part of Goldenhill Colliery. A third story is of a woman travelling on a barge to London with three men sometime around 1780 but never arriving at her destination. Apparently, police searching the canal went on to discover the headless remains of the woman on a ledge halfway along the Harecastle Tunnel. The head was never found – this tale is somewhat strange as the Staffordshire Constabulary was not founded until October 1842. This story may have become confused with the murder of Christina Collins – who did not lose her head – at Rugeley nearly sixty years later in 1839. There are no official records of a body ever being found in the tunnel, or of anyone tried for such a crime.

Some years later, workers building the Harecastle railway tunnel reported seeing a figure surrounded by mist while others have spotted the apparition at the tunnel entrance. Another sighting involved a couple driving along a road nearby when they saw 'a black dog running towards us, then it vanished.'

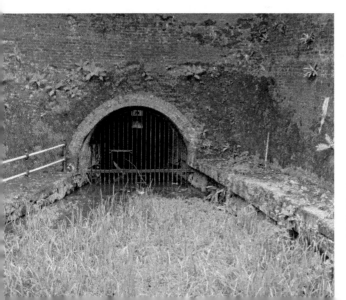

The now closed James Brindley's Harecastle Tunnel said to be haunted by the Boggart. (Author's collection)

The Murder of Christina Collins

Christina Collins, a dressmaker and daughter of a Nottingham inventor, was thirty-six years old. Widowed in her early thirties – her husband had been a stage magician – she married Robert Collins, an ostler from Liverpool. Short of work, Collins left Liverpool for London and within a short time had secured a home and employment. In June 1839 he sent his wife a sovereign (£1) so that she could join him. Christina paid her fare of sixteen shillings (80p) for the journey by boat to London, initially on a fly boat to Preston and then by canal barge along the Trent and Mersey Canal crewed by James Owen, George Thomas and William Ellis (alias Lambert).

Shortly after passing through the Harecastle Tunnel the crew, fortified with alcohol, began watching Christina and she began to worry. When the boat moored at Stoke Wharf at midday on Saturday to unload and take on more cargo the men, leaving fourteen-year-old apprentice William Muston behind, went to the nearest tavern for more beer, even carrying an extra gallon of ale back to sustain them on the journey. Following a stop at the Plume of Feathers, Barlaston, the boat arrived at Stone Lock where the crew headed into town. By now Christina was getting increasingly worried, to the extent that several people asked if she was alright. At Hoo Mill lock the keeper's wife was disturbed at midnight by a woman crying and calling out only to be assured by Owen that the lady was well. Then, as the barge reached King's Bromley, a drunken and agitated Owen told of his female passenger who had committed suicide.

At the same time on the morning of 17 June 1839, a northbound boat captained by Tom Grant was passing over the aqueduct at Brindley Bank near Rugeley when it stopped for a closer look at something lying in the water. To his horror it was the body of Christina Collins, which he subsequently retrieved from the canal and carried up the steps next to the pumping station. Later, the constables were waiting at Fazeley to arrest the drunken boat crew.

During the trial, Owen attempted to claim that Christina had committed suicide, calling the name of her husband, Robert Collins, before she jumped; however, the apprentice Muston gave evidence for the prosecution and the plea was rejected. Furthermore, witnesses from Stoke Wharf testified that Christina had complained to them about the men and also that she had carried a considerable amount of money, but on examination of her body only 1/6d (7.5p) was found in her purse. She had been raped and pushed overboard by either Owen, Thomas or both of them and died by drowning.

All three were found to guilty. James Owen and George Thomas were hanged in front of a large crowd outside Stafford gaol on 17 April 1840 while William Ellis was transported to Australia. Christina Collins was buried in St Augustine's churchyard, Rugeley.

There is a local story that following the murder bloodstains from Christina's body remained visible on the steps, giving rise to their name – 'The Bloody Steps'. Those original steps have now been replaced with concrete ones, which although stain-free still carry the gruesome name.

Exactly 100 years later, on 17 June 1939, a woman and her daughter from Rugeley saw a figure with hair tied back and wearing breaches walk on the water before disappearing through the steps. Speculation suggests it was Christina's husband Robert or maybe it was Tom Grant who carried her from the canal.

Some claim the story to be the basis for Colin Dexter's Inspector Morse novel *The Wench is Dead*.

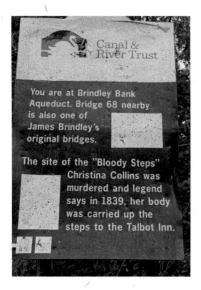

Left: The canal side panel remembering the murder of Christina Collins. (Author's collection)

Right: The haunted 'Bloody Steps' up which the body of Christina Collins was carried. (Author's collection)

Bibliography

Adams, Percy W. L., Wolstanton: Wulston's Town
Bird, Vivian, *Staffordshire*
Hackwood, F. W., *Staffordshire Customs, Superstitions and Folklore*
Jamieson, W. M., *Murders Myths and Monuments of North Staffordshire*
Mee, Arthur, *Staffordshire*
Ward, John, *The Borough of Stoke Upon Trent*
Warrilow, E. J. D., A Lantern Lecture of Stoke-on-Trent
The Newspaper Archives